CHINESE BRONZES

Cassell Publishers Ltd
Artillery House, Artillery Row
London SW1P 1RT

Translated by Pamela Swinglehurst from the Italian original
Bronzi cinesi

© Gruppo Editoriale Fabbri, Bompiani, Sonzogno, Etas S.p.A., Milan 1966,
1984

This edition 1987

British Library Cataloguing in Publication Data
Bussagli, Mario
[Bronzi cinesi. *English*] Chinese bronzes.
— (Cassell's styles in art)
1. Bronzes, Chinese — History
I. Title
739'.512'0931 NK7983.A1

ISBN 0 304 32157 5
Printed in Italy by Gruppo Editoriale Fabbri, Milan

Mario Bussagli

CHINESE
BRONZES

CASSELL
LONDON

INTRODUCTION

An ancient Chinese text, the *Tso-Chuan,* refers in passing to the semi-legendary Hsia dynasty, mentioning the marvellous works produced in 'distant regions', and a gift in metal sent from the 'Lands of the Nine Shepherds' to the Hsia Emperor, Chi. Chi was the son of Yü the Great, the hero-king who 'controlled the waters and the earth', carrying out huge canal-building projects and banking rivers in order to make the country fertile and healthy after the 'Great Flood', which according to tradition lasted for thirteen years (2085–2072 BC). The same account is given, with slight variations in *Shih-Chi* ('Historical Reports'), written somewhat later by Ssu-ma Ch'ien, the unrivalled master of Chinese historiographers. This author, who recounts the history of China from its mythical origins to the 2nd century BC, emphasises the value of metal during the epoch of Yü the Great and dates the spread of metallurgy back to the period of great canal-building.

Consequently, even allowing for the element of distortion in the legends, it seems that Chinese civilisation and the early structure of the state were influenced by one or both of two factors: the building of canals and an irrigation network, which increased agricultural production; and the importation of metallurgy from some foreign source. The legend recounted by Ssu-ma Ch'ien has it that the 'Nine Shepherds' melted the heaven-sent metal in nine magic tripods; and according to some verbal accounts—which arose much later and were of a popular character—the prosperity and even the existence of China depended on keeping the tripods on Chinese soil. It is interesting that these ancient legends, so poetic and fanciful, preserve a memory of the importation in ancient times of the technique of metallurgy, and of bronze itself, from the west. And this despite the fact that we do not know who the people of the 'distant regions' were nor who lived in the 'Lands of the Nine Shepherds'. We do know, however, that in Egypt, Iran and elsewhere, the development of metallurgy was far more advanced than in China; that the discovery of bronze alloys could hardly have occurred twice, independently, in regions so distant one from another; and that it was the people who lived in mountainous regions who developed and spread the technique of melting and working bronze.

It would not be surprising, therefore, if this knowledge came to China from the region of the Altai Mountains, an area of great metallurgical activity,

which was among the most important in Asia. It is certain that there was considerable intercourse between Siberia and Central Asia on the one hand and China on the other, although it is not possible to establish with certainty in what way they acted on each other.

The very ancient terracotta funerary urns of the pre-metallic age, for example, are evidence of a definite relationship between the cultures of China and Southern Russia, the Caucasian region and Northern Iran. Slowly developing contacts between these far distant regions can therefore be traced from the end of the 3rd millennium BC. At the beginning of the 2nd millennium an interweaving of similar and related cultures occurred over a great part of Central Asia and Siberia, with important branches appearing towards the south and Eastern Europe. These cultures have been given the name of Andronovo—a Siberian village near Acinsk—in the neighbourhood of which was discovered the first and most important necropolis characteristic of the cultures. This complex of related cultures very probably originated on the western side of the Urals, in the plain of the Volga or in the region round Moscow, and it possibly played an important part in transmitting the science of metallurgy to the emergent Chinese civilisation.

The art of bronze, in fact, seems to arise almost spontaneously in China and quickly achieves, during the Shang dynasty, technical and aesthetic standards which are unrivalled. 'Very few among the best of modern artisans in Europe and America', wrote

H. G. Creel in his famous book *The Birth of China,* 'could succeed in equalling the work of Shang bronze workers, notwithstanding our technical and scientific knowledge; and they could certainly not succeed in improving on them.' The elegance and craftsmanship of Shang bronzes suggested immediately to W. Van Heusden the idea of a lost art, the result of a technical ability which has completely disappeared. Nor did L. Sickman hesitate to declare that the standards achieved by Shang works remained unsurpassed and often unequalled.

Even though it is more likely that there was some technical influence from abroad, it is not entirely true that Shang bronze workers and their predecessors were indebted for their own magnificent work to magician craftsmen: to the wizard metal founders who are typical of Siberian and Central Asian culture during its nomadic phase. The two texts referred to belong to the second half of the 1st millenium BC. The 'Nine Shepherds', with their skill as founders and their immense occult powers, correspond exactly to the shaman type. But these wizard craftsmen, guardians of magical, religious and technical knowledge, belonged to that fierce nomad culture which, *long after the end of the Shang dynasty,* brought terror and destruction to the sedentary civilisations of two continents.

The legends in the *Tso-Chuan* and the *Shih-Chi* give not only vague hints of the ancient importation of the art of bronze from the west but also direct and exact knowledge of the technical ability of the sha-

mans who were responsible for spiritual and social order among the nomadic hordes which were a constant nightmare to the Chinese Empire. It is thought that the great phenomenon of the 'Pontine Migration' became apparent at the beginning of the 1st millennium BC as a migratory thrust from west to east, taking place over the whole region from the Black Sea to China. Unleashed in full force at the beginning of the 9th century BC, the migrations reached their climax in 771 BC with the pushing back of the Western Chou who, as much because of barbarian pressure as feudal revolts, moved their capital to Loyang, integrating with the Eastern Chou. The main role in these migrations was played by hordes of Thracians and Cimmerians, who are probably more responsible than any others for the presence in some central Asian regions of Indo-European languages very similar to Celtic and Latin, and which therefore belong to the Western group—called *kentum*—of the Indo-European languages. It is thought that it was in fact during this period that some peoples, or rather hordes, of nomadic shepherds appeared on the frontiers of China; they are shown in Chinese writing with ideograms or characters which today are pronounced *Hsien-yu, Hsun-yu, Huen-yu* or similarly. But in those times the pronunciation of the monosyllables was quite different: *Hsien-yu* was pronounced more like *Kim-mior* (Cimmerian) owing to a series of transformations and changes (which are well-documented) inherent in the phonetic evolution of Chinese.

The terrible barbarian hordes of Chou tradition consist therefore of a dominant Cimmerian element which retains its identity even here on the fringes of Chinese culture. Types of axes for war and domestic use, daggers, buckles, knotted or S-shaped ornaments, arrive on Chinese territory and attest to the analogous production of the Ordos, on the one hand, and that which is characteristic of Central Europe and of some Caucasian cultures on the other. This is because, as a consequence of the migrations, the bronze production of Western China—especially in the regions which border on Central Asia—was modified, displaying a similarity in style to the forms of the Hallstatt culture from near Vienna, which had now spread all over the Danube region. It also shows the influence of certain Caucasian cultures on which the same Hallstatt culture had had an effect. It could be, therefore, that the legends about the 'Nine Shepherds', even though they refer to a time before the nomad invasions, preserve a very vague memory of an ancient western inspiration from which all Chinese metallurgy derived. Other elements—partly imaginary—have as their basis the historical reality of the Pontine Migrations and the emergence of the nomad world—which, however, have been attributed in legend to an earlier period. In this way arose legends in which it is difficult to distinguish truth from fiction and almost impossible to identify the various strata of fantasy which correspond to various moments of history.

The mystery of the origins of bronze-working in

China therefore remains unsolved, even though it can be assumed that an important part of the technical knowledge necessary originated in the west and arrived in China through the medium of the Andronovo cultures.

The art of Chinese bronze workers almost certainly evolved in successive stages of extreme rapidity, so that in spite of beginning long after the flowering of western metallurgy, as is now quite certain, it quickly achieved standards of style and technique which were unknown elsewhere. And in particular it showed a refinement of execution which is unequalled.

It is beyond question that the art of melting and working metals was an important influence in the creation of ancient Chinese myths. Metallurgy in all its forms seemed miraculous to the layman. Those who worked metals and those who brought them up from the bowels of the earth and mixed them so knowledgeably seemed wizards who were constantly in touch with infernal forces; and all the more so because the melting operation was preceded, accompanied and followed by religious ceremonies, exorcism, and magic rites. Because of this it was thought that bronze objects such as swords and vessels had a spirit; and for this reason the mythical emperors of the so-called 'Quinary Series' are all connected with metallurgical activities, beginning with Huang-ti and his rival Ch'e You. (These emperors were credited with the organisation of the Chinese territories, which they had rescued from chaos, and with being the founders of Chinese civi-

lisation.) Ch'e You is the inventor of weapons; his head is made of copper, his forehead of iron, he eats minerals and the hair on his temples is represented as interwoven spear points. Yao, on the other hand, is the inventor of the vast furnaces for melting metals. Yü has already been mentioned. These myths were very probably written down later: it is sufficient to remark that the iron forehead of Ch'e You proves that he could only have become such a monstrous figure at a relatively late date, when iron was widely known and used.

But, even so, these mythical figures demonstrate the importance of metallurgy to the emerging civilisation of China. The bronze age in China lasted from about the middle of the 2nd millennium BC to the first centuries of the following millennium. Even when iron was widely known and the techniques of its production perfected, however, the art of bronze remained the expression of a special taste, responding even in relatively recent times to a varied, deeply felt and wide demand which affected the cultural and social evolution of the Chinese race.

The period during which this art flourished lasted three millennia. Throughout the period of its flowering it maintained a high quality in new works and in copies of antique forms. Copies were not made to create artful forgeries, as is often thought, but because of a desire to maintain intact the whole range of past styles, to experience ancient techniques again, and to revalue the aesthetic and functional validity of forms which had ceased to be used. When Chinese

founders introduced a new shape it did not therefore mean forgetting old forms. Even so, many old forms and many decorative motifs disappeared, never being used in later productions, and the use of bronze was soon mostly reserved for minor statuary, for mirrors, for special instruments, and for certain typical vessels, particularly incense burners.

Perhaps it is because of this tradition of imitation that experts, and especially modern Chinese and Japanese students, do not share the enthusiasm of their Western colleagues for the works of the Shang period. Although their full aesthetic value was appreciated by collectors of the Sung dynasty (AD 960–1279), these experts cannot forget that after the Sung period Chinese founders and artists succeeded in reaching very high standards of refinement and quality in new works and in imitations of the past as well. The art of bronze was not lost, therefore, but remained—still with all the possible variations—to attest to a special predilection for the material itself, for its plastic qualities, specially suitable for decorative effects, and finally for the patina with which time covers the objects created by the artist, increasing their value. Nevertheless, experts seem to neglect the evident superiority of the quality achieved by Shang workers over that which the great civilisation of Europe and Asia created before the 'Greek miracle'. Concentrating exclusively on the evolution of domestic production, they do not set these works in the wider context which would give the small Shang masterpieces greater value. If this were done, it would

at once become clear that Shang work is superior to (for example) the great bronze statues of Elam (cast in one solid piece, but despite this not lacking in grace and studied naturalness) and the small works of Iranian, Caucasian and Mediterranean culture, however varied or well made.

It is not widely known that the bronzes of the Shang period were appreciated in imperial Rome more than a millennium after the end of the dynasty. Proof of this is a 'Ku', a wine vessel made in the slender form of the calyx of a flower, which was recovered about thirty years ago in the sea near Anzio, together with the other remains of a sunken Roman cargo boat. This vase, which is beautiful although it is in fragments, is kept and exhibited in Rome at the National Museum of Oriental Art. It bears comparison with other Chinese bronzes (of the Huai style or even earlier) which were found here and there—in Rome itself, at Canterbury, and in Germany. Can we say, therefore, that there was a certain affinity between Chinese and imperial Roman taste, and that these bronzes were not regarded as exotic curiosities? Perhaps this Roman interest was the result of a special partiality for bronze which began to show itself in the first centuries of the empire, when bronze was widely used—for artistic furniture and various other objects as well as for monumental statues or very small ornaments. And it is likely that the technical skill of Chinese work, which is more easily and widely appreciated than its aesthetic value, made possible an intercontinental trade which must

have accompanied the silk business and must have been of considerable size: it reached the limits of the empire, the distant frontier provinces which were controlled by the hierarchy of the army. It should be remembered, however, that these Chinese bronzes were all quite old at the time of their appearance on the Chinese market. It can be assumed that they belonged to proper collections and that their choice by Western buyers, who did not dream of acquiring Indian or Persian bronzes (despite contact with them and despite their remarkable quality), was determined by the taste of the purchasers.

Doubtless it would be too bold to state definitely that the Chinese decorative style was appreciated in the Roman world, since the presence of archaic Chinese bronzes in imperial territory might have been due to various, not easily identified, circumstances. Although the extent of their distribution is not such as to permit a certain conclusion, it is nonetheless very likely that the elegance of their form was appreciated. The presence of such works in Roman territory constitutes an important fact in the complex problem of commercial relations between Asia and Europe.

CHARACTERISTICS OF THE SHANG PERIOD

The art of bronze, as has been remarked, is closely linked with the origins of Chinese civilisation. This

civilisation emerged from a complex of neolithic cultures—that is, cultures without knowledge of metals—which were the product of quite homogeneous ethnic groups. They had in common an economy which was mostly agricultural, and based on the cultivation of millet, and a practice of divination by using animal bones. The breaks and cracks caused by fire on bones, especially the shoulder blade, were 'read' to prophesy the future. These groups have been given the name 'Proto-Chinese'. Their cultures tended to gravitate towards the central plain, in the southern loop of the Yellow River, which was for a long time the heart of archaic Chinese culture; in fact it was here that the great Shang civilisation was born and flourished. Characterised by fictile (clay) products which varied greatly, these cultures have been identified in successive archaeological strata, each of which reveals events involving the rivalries, invasions and co-existence which form the pattern of prehistoric Chinese development.

The oldest of the cultures in question is the one called Yang-Shao, typical products of which are red ceramics for common use and funerary urns adorned with symbolic paintings. Flourishing for an indeterminate period between 3000 and 2000 BC, this culture extended over a vast area which includes various northern provinces of China. But it was most pure—free from admixture with other cultures—only in the Anyang region, where the last capital of the Shang Kingdom was established when King

P'an-Keng moved there with his people. The Yang Shao culture, whose pictorial decoration on funerary urns evidently bears complex symbolic meanings which are not always easy to interpret, made incursions into the west with the culture named Pan-Shan. This is also characterised by painted ceramics, perhaps made by ethnic groups which do not belong to the Proto-Chinese but nonetheless correspond chronologically to the middle period of the Yang Shao culture. The Ma-ch'ang culture in the Kansu is the third and last of the cultures typified by painted ceramics. Chronologically belonging to the second phase of the Shang period and, moreover, being a neolithic culture, it coincided with the peak period of work in bronze. Probably this is a late provincial flourishing of neolithic culture—complex enough, however, to raise the question of the actual extent of the use of bronze and to complicate the issue of the relationships between neolithic culture and the blossoming Chinese civilisation. Two other cultures must be mentioned. That known as Lungshan used black ceramics with white decoration; it might perhaps be related to the Western black ceramic cultures, though this seems to presuppose too vast a migratory movement. Hsiao-t'un (from nearby Anyang) almost certainly originated in the South, in the Huai river valley, and used grey ceramics decorated with cord impressions.

The importance of these cultures is shown by the fact that some of the typical shapes of their terracotta vessels were imitated and perfected by bronze crafts-

men, becoming characteristic forms in this medium and quite distinctive. Above all, the tripod shapes—theoretically reserved for cooking food for sacrificial offerings but considered mostly as votive family offerings and as funerary furnishings connected with ancestor worship rather than as proper works of art—testify most positively to the close connection between bronze work and terracotta. They demonstrate a continuous evolution from the proto-historic (neolithic) to the Shang-Yin period.

In Chinese the tripod forms are called 'Li', 'Ting' and 'Hsien'. Endowed from their origin with magic power, the symbolic decorations proliferated as the technique and maturity of style of the bronze founders developed. This is why the *Shih-Chi* states that the first mythical emperor, Huang-ti, created three priceless tripods which represented the heavens, the earth and mankind; and it is certain that each vessel conferred a magic and sacred quality on the liquid which it contained, vessel and liquid becoming an artificial measure of space (or rather volume) separated from the rest of the universe and able to act on it in a special way.

The oldest of these tripod forms are the Ting and Li. The Ting has a spherical form and solid feet as well as a remarkable history, for it remained in use until the beginning of the Christian era. The Li form, on the other hand, has hollow feet designed to increase the capacity of the vessel, as in similar vessels in terracotta. The Hsien form, which was designed for cooking sacrificial food with steam, and which

also has antecedents in terracotta, was designed in two parts, sometimes removable and at other times welded together, separated by a grill.

It is strange that some of the greatest authorities on the subject, among them H. G. Creel and Cheng Te-k'un, maintain that the tripod form is unknown outside China. Cheng Te-k'un is undoubtedly right in regarding the carriers of the culture known as Hsiao-t'un as most responsible for the spread of vessels with a tripod form. This is proved by the fact that in the sphere of grey ceramics this form represents three-quarters of the total production. But tripod forms with hollow and solid feet appear at Tepe Giyan and at Tepe Jamshid in Iran (although very much less frequently) up to the beginning of the 2nd millennium, perhaps a little earlier than in China, and last about as long as the forms produced in clay by the Chinese culture. In this way a new link is established between China and the Iranian west. Again, however, it is not possible to establish the exact significance of this relationship owing to the impossibility of attributing a definite date to either the Chinese works (tripod forms appear even in black ceramics in the oldest strata and in painted ceramics in the Ma-ch'ang culture) or the findings of Iranian stratography. The Chinese origin of tripod forms cannot therefore be definitely excluded; and the decorative elaboration practised by Shang bronze workers and their successors unquestionably reflects a very original taste, unknown in any other symbolic work of that time.

However, it is not only the forms of the vessels that link the oldest Chinese bronze civilisation with local neolithic cultures preceding and accompanying it. Other evidence is available in utensils and more or less valuable manufactured articles (in stone, in marble and in jade) and in some architectural features. But, above all, such a complex civilisation as the Shang could not have developed from nothing; a civilisation based not only on the technique of metallurgy and knowledge of bronze but also on a defined idea of the state and of royalty, on the use of writing and its diffusion, and on the use on a vast scale of chariots for tactical and strategic purposes. And, of course, there was a transition from the more or less permanent village groups of the first northern farmers (which followed the seasonal camps of the last mesolithic hunters) to communal centres of life which were more highly developed; and then to real cities girded by walls and containing well-defined social hierarchies. The first of the Shang capitals to be known, as a result of diggings which began as long ago as 1928, is Anyang, named from the nearest modern town. In inscriptions it is known as 'Great Shang' and is situated in a locality called Yin Hsiu (Yin clearing), a place which has thus preserved through the millennia the ancient name of the Yin, an alternative title for the Shang dynasty in its last stages. According to some Chinese scholars the capital accommodated a dozen Shang sovereigns between 1384 and 1111 BC. In fact it must have been founded by P'an-Keng some time later—probably

about 1340 BC—and must have reached quite remarkable proportions. It consisted of 'a city of the living' and of a huge necropolis which reveals an incredible number of tombs (among which are almost certainly some royal ones) and graves for human sacrificial victims. To judge from the evidence provided by diggings carried out in sectors often distant one from another, the city must have been rebuilt towards the middle of its existence. Some sacrifices may be connected with this reconstruction, such as those of the 'guardians' of the gates and their servants, who are buried together with splendid arms and rich plate, or that of five chariot crews—complete with men and animals—buried with their weapons of war. Some idea of the size and organisation of this city is given by the houses underground, or in grottoes, by foundations of temples and palaces, shops, warehouses, wells and underground granaries for storing provisions; while from the remains it seems clear that human sacrifices were common in Shang society. We know, however, even from inscriptions, that Great Shang was not the only capital of the dynasty. Another older urban group in the form of a square came to light as a result of the fortuitous discovery of pottery on the surface of the soil. This second great city, situated near modern Cheng-chow, is almost certainly the ancient city of Ao, the second Shang capital, which is spoken of in the *Annals of Bamboo* and in the *Shih-chi*.

To judge from what has so far been discovered, Ao was a good deal less wealthy than Anyang and the

taste of its inhabitants less developed. In fact its status as a capital is revealed almost solely by the enormous surrounding wall, which makes it a fortified centre of the first importance, and which at its base is at least twenty metres thick at the weakest points. Only one sector of the diggings—the Public Park of the modern city—has revealed strata contemporary with Anyang; all the other strata are older. This means that the city developed before the foundation of the Anyang capital. After the transfer of the royal court, which entailed the removal of all the religious and organisational bodies which functioned at the principal centre of the Shang state, ancient Ao survived in only a limited way, even with respect to its urban area. It follows, therefore, that the lesser refinement of bronzes from strata earlier than the foundation of Anyang is due to a chronological difference and not a qualitative one. This was not realised at first, and the works of the Cheng-chow area seemed provincial productions compared to those of Anyang; for at this time it was not possible to establish a relative chronology which would relate the two areas in time. That it is a question of chronological differences is confirmed by the absence of inscriptions on bones used for predictions which have been discovered in the Cheng-chow area (except for two which belong to different strata). This reveals not only a more limited knowledge of writing but also a very different and more rudimentary organisation of rites and of the prophetic archives. This is significant in view of the fact that nearly every

activity, however important, whether of state or court or aristocracy, was regulated by this type of divination.

TECHNIQUES

The art of bronze developed in China somewhere about the middle of the 2nd millennium BC. It underwent an evolution in techniques of working, in form, and in the development of symbolic decoration, which must have been very rapid in its initial stages, and which never entirely ceased, even when the Shang bronze workers had become great masters of their art. It is clear, moreover, that the Chinese had a special flair for metal working which displayed itself in a relatively short time, and that they were able to assimilate methods for smelting and working quickly and easily, perfecting them in an unexpected way. This Chinese flair reveals a very special aspect of archaic Chinese thought, which could encompass artistic creativity and technical complexity. Besides, technique aroused a profound interest for its own sake, not very different from that which we can find in the West among the best craftsmen before the industrial revolution. On the other hand, the aesthetic development which preceded the evolution of symbolic decoration denotes the formation of a special autonomous taste based on a preference for curved lines and, above all, for sections of an ellipse. The establishment of this taste was made easier by tech-

nical progress. In fact the precision and subtlety of the decoration, the effects which are based on the 'lightning motif' ('Lei-wen' in Chinese, also called the 'square spiral'), seem to be the result of meticulous and patient work with a chisel.

It is thought—as we shall see more clearly when we examine the symbolic motifs—that the images which decorate the sides of the vessels, the handles of weapons and utensils and the bronze trimmings on war chariots, try to express a vaguely demoniac character but avoid giving a distinct physiognomy to the monstrous figure which represents him. This is the famous T'ao-t'ieh which appears in the terminology of Sung antiquarians.

For this reason he appears on a wavy background—which is also found on contemporary white ceramics —assuming a form and substance only revealed by the relationships between the various geometrical motifs of which he is made up, chief of which is the Lei-wen. In view of the facts that the work could not have been done with a chisel at this time, and that very numerous founders' matrixes have been found in the diggings, it is tempting to suppose that the finest vessels and other objects were produced by the *cire perdue* method, that is to say the one used by Benvenuto Cellini in casting his Perseus. But more recent research, using the most modern methods for studying metals, positively rejects the use of this technique. Although it seems impossible, and although the skill of the Shang metal founders appears superhuman, all their works were made by direct casting,

either in one piece or in sections. This casting was executed with a clay mould which was broken once the work was completed (the positive from which the mould was made must often have been made of wood) or with some durable mould, in various refractory materials. It is not known whether the latter was used several times or only once. Some of these moulds retain tiny particles of bronze in the folds and corners, which shows that they were used for casting. (It must not, however, be forgotten, that moulds of this type were used to cast objects in quite hard clay from which the more fragile mould was taken and destroyed.) The technique employed necessitated a profound skill in using the apertures for the introduction of the melted metal or for the discharge of air in order to prevent defects and air bubbles. The remains of portable containers for the molten metal have been found; they were needed because in most cases the work called for relatively small quantities of metal and did not justify direct channelling from the furnace. The process was completed by a meticulous finishing and polishing which was quite extraordinary in view of the technical means available at the time.

Analysis of bronzes shows great variations in the composition of the metal, depending on the object to be cast and the use for which it was intended. The metal used was hard for arms and utensils (an alloy of zinc and small quantities of iron, metal and antimony), more flexible and vibrant for drums and bells (increasing the amount of tin), and lighter for arrow-

heads (lead, always present in various proportions, now disappears and copper dominates). This reveals how rigorous the researches of the metal founders were. The differences between bronze alloys arise sometimes from voluntary additives but more often from the nature and varying composition of the ores from which the metals were extracted. The iron founders learned from experience to use metals coming from one locality or another, according to the type of object to be cast. Often, as William Willetts points out, the mines were a long way from Anyang, and the frequency of the word 'T'ung' (written with the ideogram which means copper) among the place names of Northern China seems to indicate the presence of copper ore mines which today are exhausted or abandoned. The most used of the ores was, without doubt, malachite.

DIFFERENT TYPES OF BRONZES

Bronze vessels often bear dedications to one or more ancestors, incised on the inside. A little less than half of all known vessels carry an inscription of this type, which means that there are more than 15,000 inscriptions, nearly all very brief. Very often the ancestor is not referred to by name but is given a symbolic designation. This must have referred to the calendar, probably indicating the day, decade, month or year

when prayers or offerings were made in his honour. The inscription ended with a family or group emblem derived from very old ideograms which were replaced by the writing we call archaic. The votive and ritual character of such vessels is therefore perfectly clear. The use for which they were designed, in theory—for in practice their significance was that of precious objects with symbolic and magic properties—suggests a grouping of them in the following categories:—

1. *Vessels for the preparation and cooking of sacrificial food.* This is the category that includes the tripods and the rectangular four-footed 'Ting'.

2. *Vessels for storing sacrificial food* (called 'Kuei' and 'Yü').

3. *Vessels for heating 'wine'* (a blackish liquid made from fermented millet). These include tripod forms, some of which are very elegant, for example those called 'Chia' and 'Chüeh', both with pointed legs and often with unusual little pillars which protrude from the edges. These were also used for libations and their form is doubtless the result of meticulous aesthetic research, conditioned by symbolic meanings which are not clear, and a relative indifference to function. Very different is the 'Ho' form. This is a kind of teapot with a tubular spout, a handle and lid, with a three-lobed or round body and three (or four) cylindrical legs.

4. *Vessels for storing 'wine'*. Some of these, like the 'Tsun' and 'Kuang', are modelled in fantastic or stylised animal shapes, and achieve the stature of

sculpture because they define the interior volume of the vessel by aesthetic means.

5. *Vessels for tasting 'wine'.* The flared form of the 'Ku', which is similar to the corolla of a Canterbury bell, is without doubt one of the most elegant creations of the Shang founders. This is so even when the structure based on a circle is replaced by a square (a not unusual stylistic process tends to link the two geometrical forms); the aesthetic quality of the Ku transcends its functional use. The 'Chih' form looks like a big bulging beer tankard with a hinged lid.

6. *Vessels for water.* Wide and shallow, without handles, these must have been designed for ritual ablutions. They all have a circular base.

The plastic value of these works is certainly remarkable. The most favoured forms, especially those which feature animals with more or less fantastic shapes, confer on the vessels something of the quality of sculpture, either in a stylised or abstract form.

The search for form reveals a well-defined and unmistakable taste as well as great creative flair. There remains, however, the problem of the origin of the forms themselves. These animals are conceived as creatures without movement and this often leads to such an extreme stylisation that the motif becomes abstract even though what might be called the realistic basis is never obscured. At times, as happens above all with Kuang objects, the animal form is identified and becomes integrated with that of the vessel; this perhaps results from a desire to

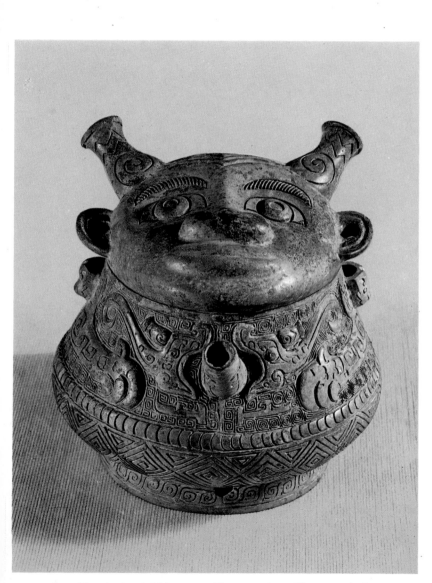

1. Ritual vessel with spout. Ho type. Late Shang period or early Chou. Freer Gallery of Art, Washington.

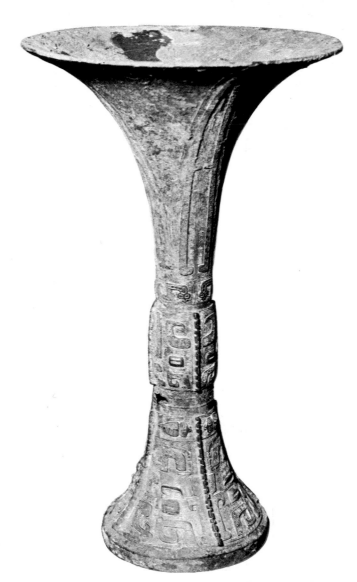

2 . Chalice. Ku type, from Anyang. Shang period. W. Rockhill Nelson Gallery of Art, Kansas City.

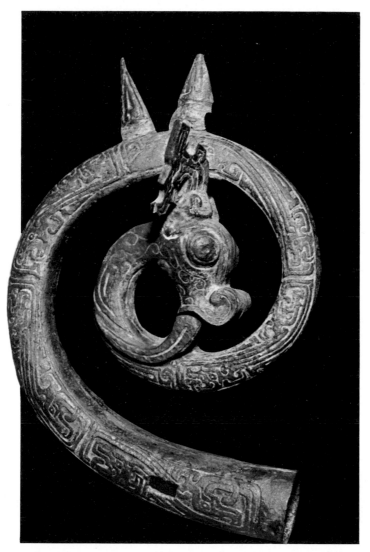

3. Spiral ornament with dragon's head and neck. Middle
Chou. W. Rockhill Nelson Gallery of Art, Kansas City.

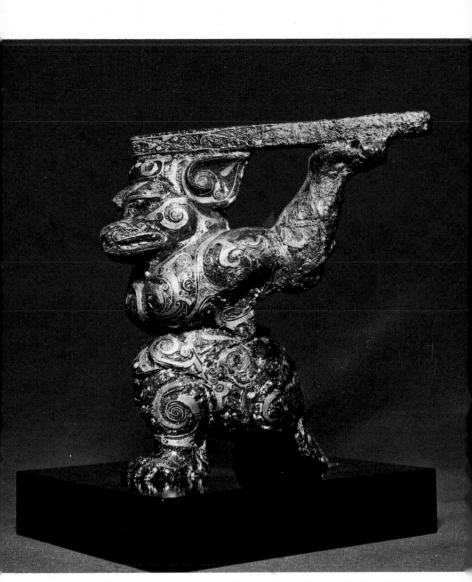

4. Table leg or support in bronze. Late Chou. W. Rockhill
Nelson Gallery of Art, Kansas City.

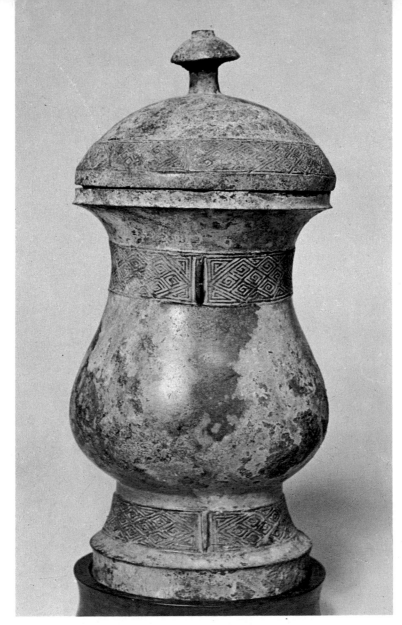

5. Bronze container, Chih type. Badalich Collection, Milan.

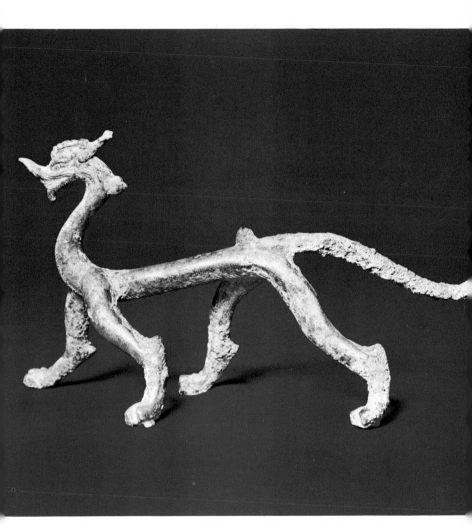

6. Dress ornament in the form of a stylised dragon. Late
Chou. W. Rockhill Nelson Gallery of Art, Kansas City.

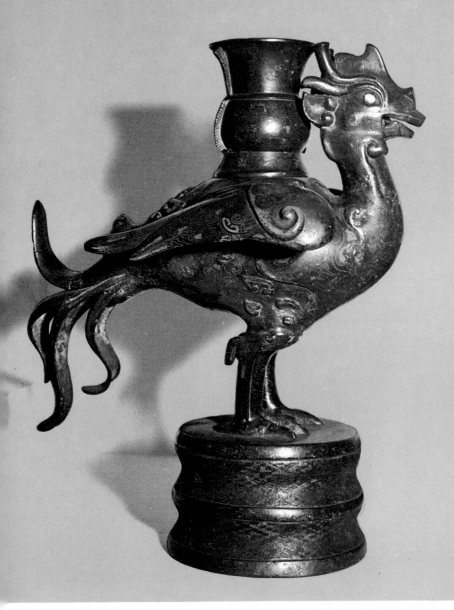

7. Vessel in the form of a stylised cock. Early Ming period.
British Museum, London.

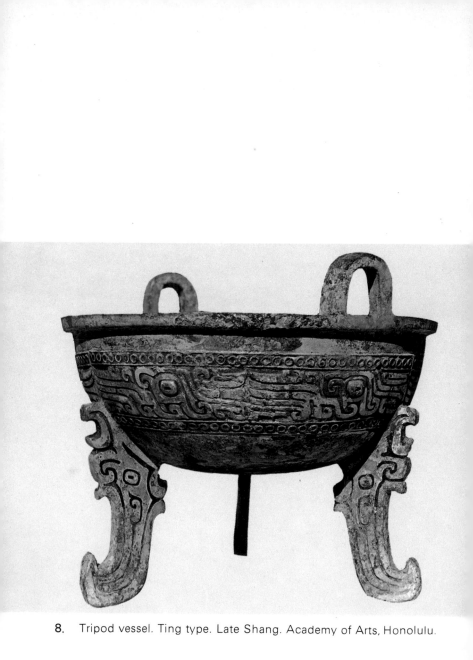

8. Tripod vessel. Ting type. Late Shang. Academy of Arts, Honolulu.

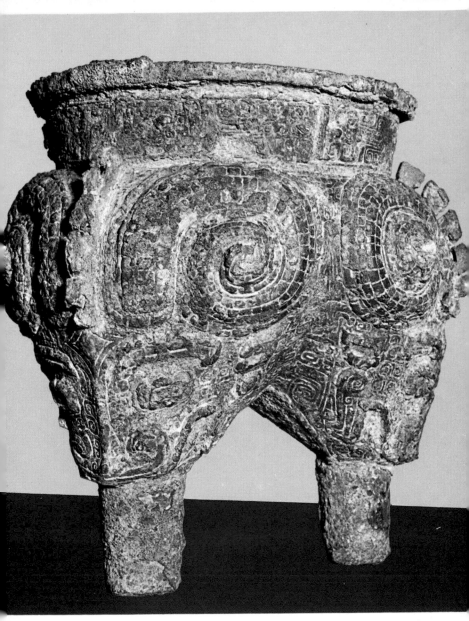

9. Tripod vessel with hollow legs. Shang period. Musée Guimet, Paris.

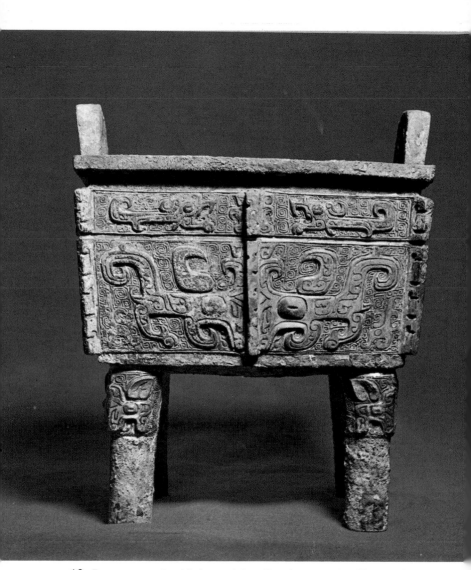

10. Bronze vessel with looped handles (rectangular Ting type).
Shang period. W. Rockhill Nelson Gallery of Art, Kansas City.

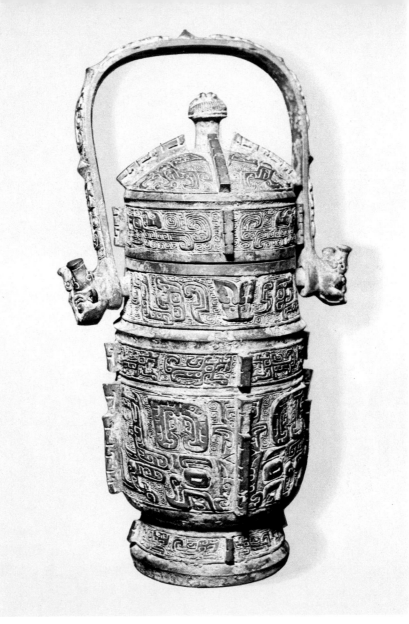

11. Vessel for storing wine. Yü type. Chou period. W. Rockhill
Nelson Gallery of Art, Kansas City.

12. Ritual water vessel decorated with a Lei-wen frieze. Late Shang period or early Chou. Musée Guimet, Paris.

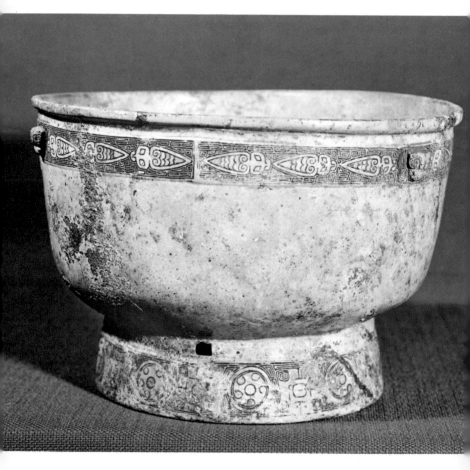

13. Vessel for storing wine, Yü type. Middle Chou. Museum of Fine Arts, Boston

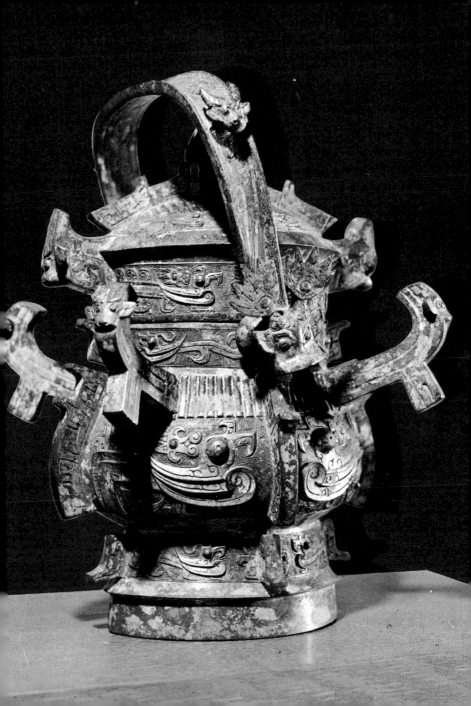

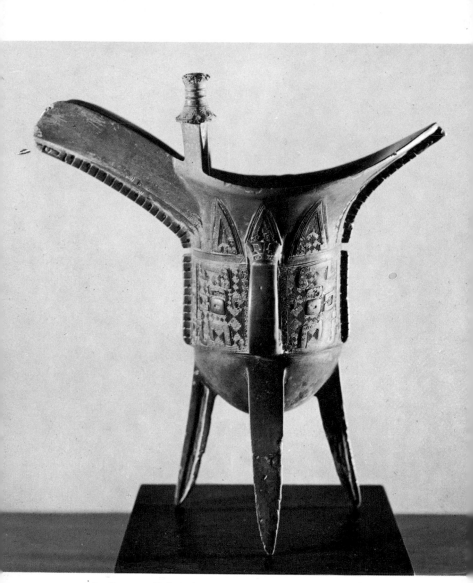

14. Bronze Chüeh for libations of warm wine. Late Shang.
Freer Gallery of Art, Washington.

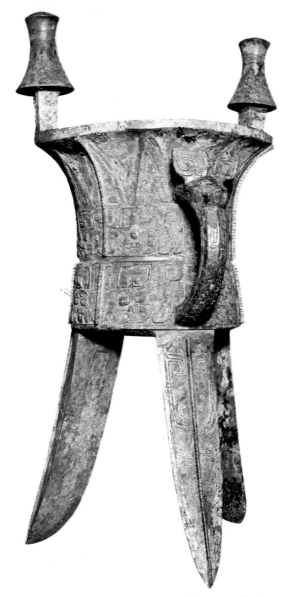

15. Tripod vessel. Chia type. Shang period.
W. Rockhill Nelson Gallery of Art, Kansas City.

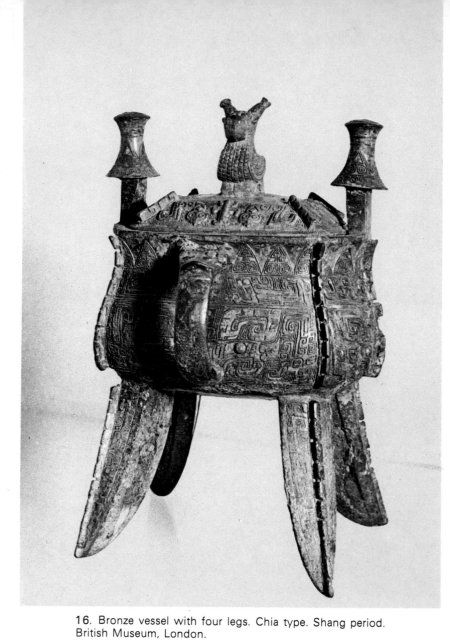

16. Bronze vessel with four legs. Chia type. Shang period.
British Museum, London.

merge the animate and inanimate in one chaotic vision — which is perfectly in keeping with the search for the symbolic which is part of all Shang decoration. Other forms usually reveal their origins quite clearly, as happens with the *ku*, which are probably cups made from animal horns. Some though are more puzzling, even those that have their roots in terracotta. Modifications are suggested in the more plastic material and in the techniques used, as the demands of rituals become demands of taste. For us, certain shapes, while highly valued as abstract sculpture, are less clear as to function, to the point of being almost incomprehensible, although one can image their impact in ritual dances with their slow solemn gestures from the effects of the wine and their rich symbolic beauty.

But bronze makers did not limit themselves to vessels. The blades of the spear which the Chinese called *ko* are one of the main products of Shang artisan work. Some of these were used in rituals whose use was inscribed on them. For example, those with *ta-yu* (heavy rain) written on them indicate what the *ko* was meant to be used for – as an instrument, more magical than liturgical – in rain rituals. But, above all, the *ko* was one of the main weapons used by the Shang infantry. Similar to a dagger with a wide blade and a short flat usually perforated handle, it was attached crosswise to a longish wooden handle and served as a spear or dagger. The heavy axes and knives show that the Chinese infantry was provided with armour suitable for close combat. The chariot crews consisted of three people: the charioteer, an archer, and a pikeman, who was armed with a very

long spear with a heavy bronze point. Even the axes and knives—the blades of which were perforated with graceful ornamented motifs—were sometimes instruments of worship, as were the vessels, the bells and perhaps the tips of the flagpoles, which must have had symbolic meanings of a religious character but perhaps also contained heraldic implications.

Another problem is presented by the curved knives in bronze, which were perhaps derived from flakes of splintered stone or from prototypes in horn or ivory. Their curvature, which is slightly concave, includes both blade and handle. The handle may be surmounted by a ring or the head of an animal. The form remains substantially the same for centuries, but even so there stand out conspicuously a series of variations partly arising from aesthetic reasons and partly determined by differences of function. It is probable that these knives were initially for everyday use, perhaps as agricultural implements (for example as sickles for cutting grass); but with the passage of time they were also introduced into rituals. This is shown by the symbolic ornaments on the spines of the blades which, although perforated and fragile, could also be used for practical purposes.

This type of product raises another archaeological question. The number of knives found in widely separated localities, especially in the Chou period, is so great that it suggests that they may have become a kind of coinage used by Central Asian and Siberian peoples. If so, they would have had a double value: that of their bronze content and that of the object

itself. The value of the latter must have been well appreciated because, although many imitations of Chinese knives in one style or another have been found, their quality, especially the toughness of the metal, is clearly inferior. Be that as it may, the exact reasons for the spread and rapid increase in the numbers of objects of this kind (towards the 8th century) are unknown. The 'barbarian' imitations show clearly the extent of the intercourse between China and the Central Asian world, which is unequivocally demonstrated by this simple object which generally speaking has no aesthetic value other than that of its basic shape.

THE STYLE AND SYMBOLISM OF RITUAL VESSELS

The artists who created the vast number of ritual vessels during the Shang period often saw their work not as containers which had to be embellished and decorated, but as complicated sculptures with a functional use. They were instinctively attracted to a total effect which merged traditional forms, various symbolic meanings, a ritual function and the aesthetic effect of the modelling. This becomes particularly clear in the zoomorphic vessels and in those in which

the symbolic values are most marked. Nevertheless the decoration on the sides and body of the vessels is so important, so complex, so charged with varied symbolism that two different methods of critical evaluation have been formulated. The first considers the work in itself and studies it from every point of view; the second particularly stresses the decoration and 'grammar' of the symbols and the stylistic meaning, and tries to establish their precise significance. The American Max Loehr and the Swede Bernhard Karlgren are the leaders of the two schools, which are often regarded as opposed but which are in fact complementary.

Karlgren divides the Shang-Yin period into two different styles. One of these, style 'A', is characterised by the heavier relief of the incised decoration and by its distribution on the surface of the vessel, which is designed to render a greater plastic effect. The decoration, which is very clear, nearly always emerges from a background completely covered by the 'square spiral' motif; it has clean outlines and certain raised surfaces through which the vessel itself acquires the character of a plastic structure. The details—the raised and concave sections, corners and squared surfaces—are emphasised in such a way as to give an impression of unity which corresponds to that of sculpture. The other style, 'B', is dictated by the shape of the vessel. The decoration in this case seems to have been incised by a chisel; it is delicate and fine, and therefore shows up less clearly and legibly, like a wavy background.

Max Loehr maintains that style 'B' is in practice associated with geometrical decoration, without zoomorphic symbols, of the white ceramics and terracotta which are characteristic of the Siberian and Central Asian cultures of the Andronovo group. The animal motif, with its fantastic images of monsters as well as of real beings, broke into the complex system of geometrical decoration for magic and religious reasons—as if there were a desire to achieve a more precise meaning, a significance which would be more valid and different from the symbolic implications of the simplest geometrical patterns. It is difficult to ascertain where this animal motif came from. It could have originated in the Baikal culture, which was more complex and highly developed than was realised before recent archaeological discoveries; or it could have spread from the distant regions of the south-west, that is to say derived from painted terracotta objects from the Iranian or Indo-Iranian cultures, where mastery of stylisation of animal forms went hand in hand with an ability to render such forms realistically, especially in full relief. (In this way they differed from the Baikal cultures, in which the best work shows absolute truth to life but which produced little of value when attempting vaguely stylised images.)

The style of animal motifs in Chinese sculpture varies considerably in different objects. The predominant image is the one called 'T'ao-t'ieh', a monster without a lower jaw and reduced to a mask seen from the front, which with its huge and malev-

olent eyes stands out very little from the geometrical decoration of the background. Horns, crests, fangs, taloned paws are composed into a geometrical decorative pattern which becomes nearly abstract after going through a process which separates these features from the body by deforming and stylising them until they are almost unrecognisable. The impression given is no doubt deliberate: of a vaguely malevolent presence which is intuitively felt, rather than seen, on the sides of the vessels. The mask is shown front face, thus establishing an immediate relationship between it and the person looking at it. This indicates that the image possessed magic powers: all the frontal images in ancient art have this kind of significance (usually a malevolent one), beginning with the Indian 'makara' and the classical gorgon and going on to the Medieval convention —maintained during Renaissance times—which ordained that Judas should be shown side face so that the demoniac powers of the traitor should not disturb the serenity of spirit of the faithful. Later, during the Chou period, the T'ao-t'ieh is composed of various animal images which go side by side or are added to a larger figure in order to impart a certain ambiguity, a result of the combination of various images, which are given a rather stiff form by clever stylisation. At other times, although more rarely, the figure itself has more definite lines and features, becoming a hybrid creature which is both bull and lion. The magic properties of the original are, however, lost here, and only its hybrid composition acts

as a reminder of the original striving towards a menacing and potent formlessness. This process of development, clearly directed towards a greater definition of the figure, makes Max Loehr's theory very plausible. He considers that style 'B' was co-existent for some time with style 'A', and reveals the efforts made to give an immediate and clear meaning to the already existing geometrical decoration. The only possible exception to the theory is raised by the date of the Andronovo culture which, although fairly accurately estimated, is still open to question. The symbolism of T'ao-t'ieh is, however, bound to the idea of formlessness and is expressed, even in stylised work, in the way already described. The T'ao-t'ieh (the traditional name, though probably incorrect) can be seen in different forms, but these do not obscure the essential unity of its symbolic meaning. It expresses the idea of the spirit of darkness, often given the form of a tiger or a bear, which represents the primeval chaos from which life originates and by which it will again be engulfed. For this reason there sometimes appears in the monster's throat a decorative motif which careful examination reveals as a stylised but fairly realistic image of the larva of a cicada. Because of its asexual characteristics and its underground birth, this creature represented the essence of life, which emerges from chaos and darkness, the origin of the various and contrasting aspects of life itself, male and female, light and darkness, life and death, solid and liquid, black and white. The same significance is later attributed to the silk grub

which, imprisoned in its cocoon, prepares for its metamorphosis into a splendid butterfly. In some cases, however, the cicada larva, which during the Han period (206 BC–AD 220) became the symbol of immortality and resurrection, is replaced by a human image. Because of its childlike characteristics and its posture, typical of that given to bodies prepared for burial, the image represents humanity sleeping in the earth's bosom—or rather in the bosom of those chaotic and measureless cosmic forces which give it birth, grant it life and cause its destruction. An example of this symbolism is found on the famous urn at the Musée Cernuschi in Paris and its replica in the Sumitomo Collection in Tokyo. The monstrous creature, a tigress lacking a lower jaw, holds between its front paws a crouching human being which clings to her almost as if seeking protection. The animal itself is a composite figure: the tail becomes the trunk of an elephant, whose head becomes the distorted backbone of the monster. Dragons and other animals complete the decoration, as for example the heads which act as the clasps of the rounded handle and the fawn on the lid of the urn itself. The human being is a hermaphrodite or the homunculus of alchemical lore, and it is from him that the whole of humanity emerges from the abyss of chaos. The presence of salamanders on the sides of the vessel, and above all the figure of a tadpole accompanied by fish incised on the exterior of the base—in a place not normally visible—shows that the vessel itself expresses the idea of life and fertility:

for the salamander larva leaves the water at the moment of its metamorphosis and begins to live on land. The symbolism of the composition is clearly more complex than might have been suspected, and is in its own terms completely rational.

The symbolism and stylistic and iconographic solutions of ancient Chinese art had the good fortune to survive. The cicada larva, characteristically symbolic of hope and resurrection, became part of the religious symbolism of the Sarmatians, and they transmitted it to the Goths and Franks; thus in Merovingian art the cicada larva, depicted in the Chinese style, is a symbol of resurrection occasionally used. Other aspects of Shang symbolism, on the other hand, coincide with those used in pre-Columbian America. Certain vessels of the Peruvian culture called Chancay, for example, correspond in detail with the Chinese urn in the Musée Cernuschi, as Carl Heutze has shown. There is some slight modification of the symbols used, for example the substitution of a jaguar for the fawn, to indicate the East, the source of light. And on the bases of huge vessels shaped like statues, such as the one dedicated to the Goddess of the Earth in the Mexico Museum, we find the image of a frog which has a very similar meaning to that of the tadpole or salamander. It is difficult to determine how the use of these symbols spread eastwards but it is unlikely to be a coincidence that they are found in the western region of the American continent, and especially along the coast, exposed to Asiatic migrations from very early times.

With the T'ao-t'ieh there also appear other animals. One of these, as we have seen, is the salamander; another is a kind of sheep, called Muntjak in Mongolian, the point of whose horns have a characteristic rounded outgrowth. The figurative motif drawn from these inefficacious means of defence—until some time ago called the 'button horn motif'—recurs in various T'ao-t'ieh masks, demonstrating that even Muntjak sheep were endowed with symbolic and magic powers. These were obviously connected with the practice of divination by interpreting bones, since the majority of the bones used for this type of oracle are those of ewes or rams. Probably these sheep were thought of as creatures with demoniac powers. This may be confirmed by the fact that some of the dragons, called K'uen (spectral demons), have the type of horn characteristic of the Muntjak sheep. These horns are almost habitually used as ornaments on the fantastic animal forms which decorate the lids of many Kuang vessels. On the other hand, during the Chou period we will find bronze vessels modelled in such a way as to produce realistically the likeness of rams.

CHOU BRONZES

Chinese tradition names the year 1122 BC as the one in which the Shang period ends and that of the Chou begins. The Chou were the feudal landlords of the frontier provinces; they moved from Northern Shen-

su to conquer the central plain and obliged the last Shang ruler to commit suicide. Research has put back the traditional date to 1027 BC, but this has not entirely solved the problems posed by Chou chronology. Nor does the opinion of most Chinese historians, which presumes a common race and culture for the Shang and the Chou, appear to have any foundation. The form of government which the Chou adopted—a rigid feudal hierarchy—is fundamentally different from that of the Shang, in spite of the fact that writings of the Chou period urge rulers and dignitaries to follow the example set by the best Shang sovereigns, to maintain ancient ceremonies and to study the great personalities of the previous dynasty.

The revolt and career of conquest of the Chou people was planned by Prince Wen, who assumed the title of King, becoming the 'Appointed King'; but the execution of the plan, which was meticulous and precise, was carried out by his son Wu, the 'Martial King', who broke Shang resistance in one decisive battle. The new lords, whose object was conquest and complete dominion over all the Chinese territories, transferred their capital to a site near modern Loyang, in Honan province. Their headquarters, however, remained at Ch'ang An in Shensi, a city which from this point becomes very important in Chinese history. The Chou period is traditionally divided into the Western Chou phase, which lasted till 771 BC, and the Eastern Chou, which came to an end during the purely nominal reign of King Chou,

at the time of the 'Warring States'. In 22 BC the ruler of Ch'in—a frontier province of great military power —assumed the title of Shih Huang-ti, 'First August Emperor', and founded the Chinese Empire.

Chinese society during the Chou period underwent great changes in religious, economic and administrative outlook. Confucius and Lao-tzu, for example, began their missions when the dynasty was still at the height of its power and its economic life seemed to be evolving rapidly, not only by an intensification of contact with the West but by the inevitable consolidation of the internal Chinese market.

The first phase of Chou bronze production does not appear to be very different from the preceding period, though there are small changes in decorative taste, especially in the incorporation of minor ornamental motifs into more complex forms. But the study of types of vessels produced soon reveals a change. With the closing down of Anyang foundries soon after 1000 BC some of the most elegant forms, such as the Chüeh, Chia and Ku and certain varieties of Tsun disappear. This results in part from the displacement of the centre of bronze production, which becomes less intense as it is spread over a wider area, but is also indicative of a change in the religious ritual and taste whose needs had been met for years by the local schools of the Anyang founders. Now large bowls of the Kuei type became the most common products and grew in size and weight. The T'ao-t'ieh and the K'uei dragon become more clearly defined.

The inscriptions were to disappear almost completely with the advent of the Eastern Chou style, owing to the profound change that took place in Chinese religion; but at this time they reached a length unknown in the Shang period. This was because they took on the character of a descriptive document stating the reasons which had led to the ordering, casting and dedication of the vessel, often political reasons. A religious element persisted, as can be seen in the following, which is one of the shortest: 'The third month of the third year the King . . . made known to Jung and to the Minister of the Interior an order which went like this, "We consign to the Marquis of Hsing, in return for his services, the following three groups: the people of Chou, the people of Chung and the people of Yung." The marquis, bowing and prostrating himself on the floor, prayed for the Son of Heaven [the King]. "May he prosper . . . and [the Supreme God] allow you to hold the Chou Empire forever. I, moved by filial devotion, and happy to have been acknowledged as . . . a deserving servant of the Son of Heaven, register the King's decree in order to commemorate this propitious event, having made this ritual vessel which will be used for sacrifices to the Duke of Chou [a distant ancestor of the King]".' (A partial translation of an inscription on a vessel in the British Museum.)

Classifying the styles of Chou bronzes presents some difficulty because of lack of material from thorough diggings and various chronological un-

certainties. The first phase, Yin Chou, must—even at the most generous estimate of its duration—have been ending towards 900 BC, lasting a little less than a century. It displays strongly marked stylistic and ideographic derivations from the previous period; these make it in many cases impossible to attribute to one dynasty or another those objects which because of external circumstances cannot be dated. The second phase, which is sometimes called the 'middle Chou', though this description is not terribly accurate, lasts from about 900 BC to the end of the 8th century. Then comes the 'late Chou' phase, which includes the 'Warring States' period, and which runs into the Han period. A special group of Chou productions is described as the 'Huai' style; the name refers to the principal area from which these works come, which is situated in the valley of the river whose name it bears. The name expresses both the characteristics of the style and the topographical location. Some scholars include the Huai style—with its variant the 'Chin ts'un' style, which is widely found in inlaid steel work—in late Chou. In spite of chronological uncertainties, which available material is insufficient to dispel, it can be accepted that the Huai style is a special trend within the late Chou, beginning a little before the end of 'middle Chou'.

Putting aside the products of the first period, in which the stylised motif of a bird already appears and little by little completely replaces the 'K'uei', the second phase is characterised by much less delicacy and refinement in bronze work, but also by an ex-

pressive power, bordering on the monumental, un-known in Shang times. The tigers, such as those at the Freer Gallery in Washington, are filled with an extraordinary vigour. Their tense crouching bodies and ferocious jaws with serrated teeth express all the destructive force of creatures which seem to spring out of the darkness of prehistory or a monstrous nightmare; and although they are rendered very realistically, they are not lacking in demoniacal power. Despite their function as vessels, they must also rank as sculptures. For the same reason the ele-phant at the Musée Guimet is a piece of sculpture, although of a completely different type. The short trunk and stylised jaw make this almost a caricature, although it also displays a certain preciosity of style.

The vessels are now much less ornamented with magic symbols but in compensation have a far more powerful expressive value. But the diminution of their magic or religious significance did not mean that they ceased to arouse man's cupidity to a pitch at which it directed his actions. In fact there are records of violent encounters between feudal lords which were settled by the cession of a set of vessels, and of revolts which were pacified by the same means. The aesthetic quality of the bronzes continued to advance, and Chou production shows a progressive elimina-tion of rough and clumsy work, especially in deco-rative motifs, which become elegant and extremely refined. This became possible because of new tech-niques for smelting and working the metal which partly derived from those used in iron founding.

An inexplicable return to the past then took place, a rebirth of the characteristic traits of Shang bronzes and of those of the first phase of the Chou period, although probably without their original magic significance and now appreciated for their decorative effect. The T'ao-t'ieh reappeared with the K'uei and various geometrical motifs (among them a plaited T which we will find again, used for mirrors) together with others which are quite new additions to the Chinese repertoire.

These changes and swings in fashion depended in part on the internal evolution of Chinese taste, but were also in part due to the influences which came from the west, where the so-called 'art of the Steppe' had spread and become established. Because of its great originality and vigour this nomad art covered a wide area over a long period and influenced a great part of Europe as well as Asia. It is in the Ordos, a region centred on the great western loop of the Yellow River, that this art developed a special characteristic which linked it with that of the Altaic (Siberian) and Scythian regions to form the 'triumvirate of the Steppes'. This art is based essentially on metal craftsmanship and is rich in invention and immensely skilful in style and technique. Thus the problems posed by the encounter between the Chinese and the Sino-Siberian culture of Ordos disappear. The common use of buckles, hooks and brooches in late Chou and Han bronze production indicates without a doubt that the art of the nomads had a profound effect on what the Chinese produced.

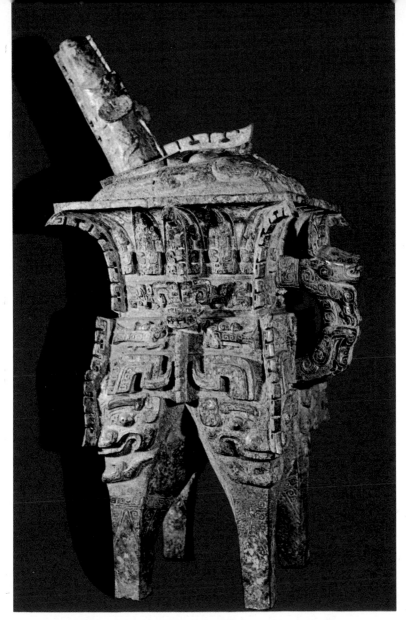

17. Vessel of the Ho type for warming wine. Late Shang period or early Chou. Nezu Art Museum, Tokyo.

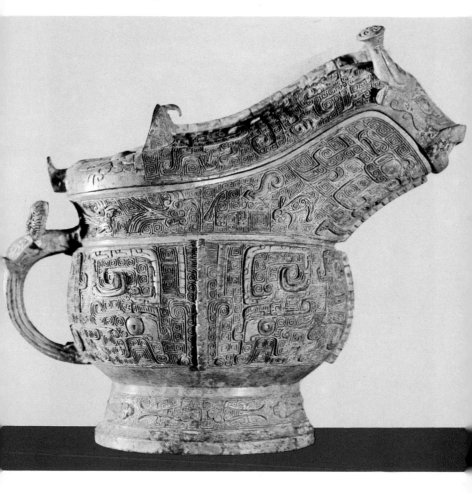

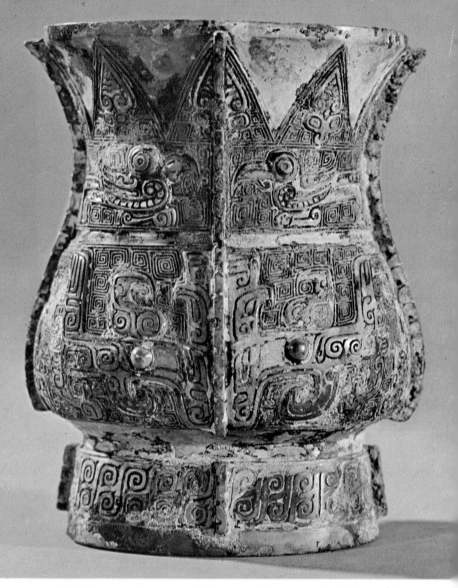

20. Large wine cup. Chih type. Shang period. Vannotti
Collection, Lugano.

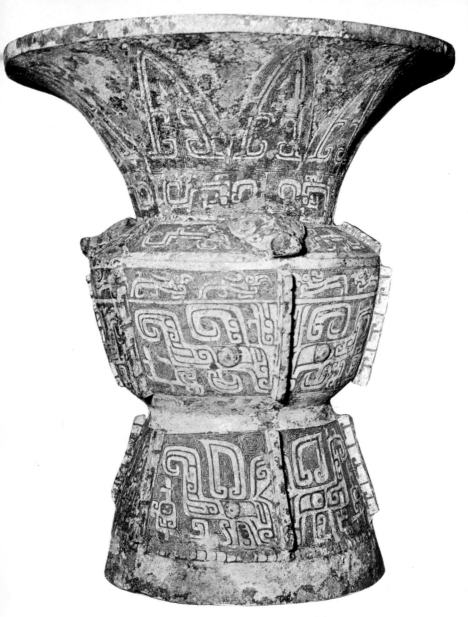

21. Wine vessel. Tsun type. Shang period. Metropolitan Museum of Art, New York.

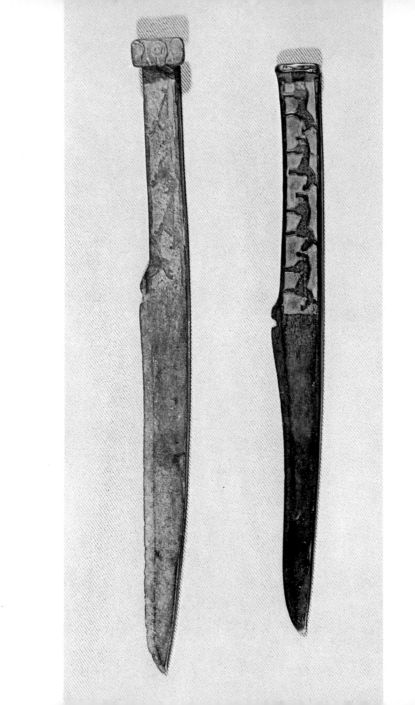

22. Pair of curved knives. Ordos art. Musée Cernuschi, Paris.

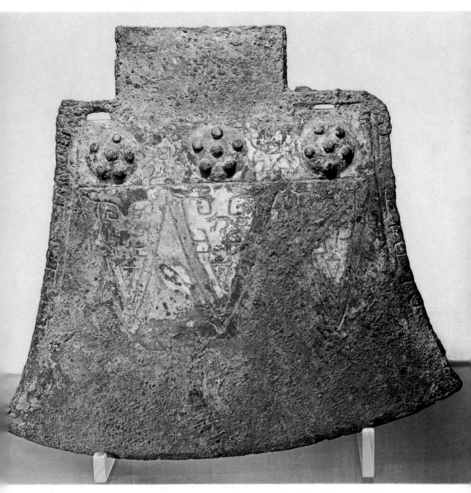

23. Bronze axe head. Shang period. Musée Guimet, Paris.

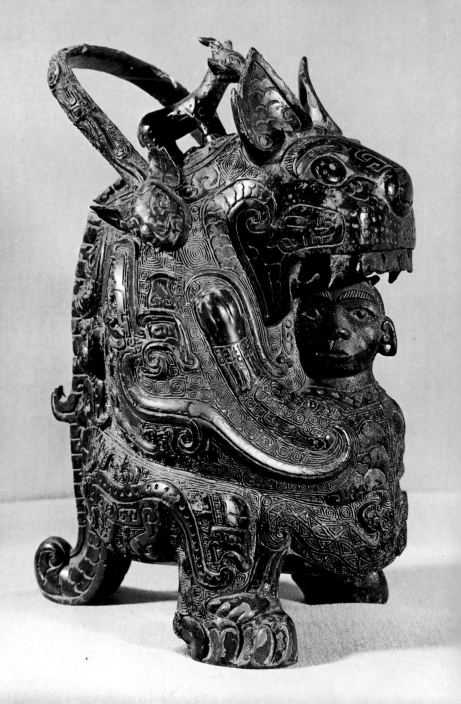

24. Urn or vessel. Yü type. Shang period. Musée Cernuschi, Paris.

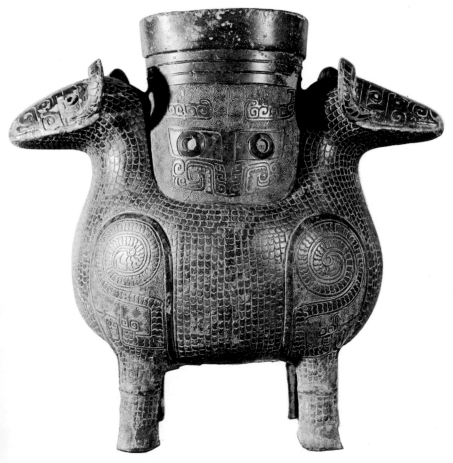

25. Wine vessel formed by the foreparts of two sheep. Early Chou. Nezu Art Museum, Tokyo.

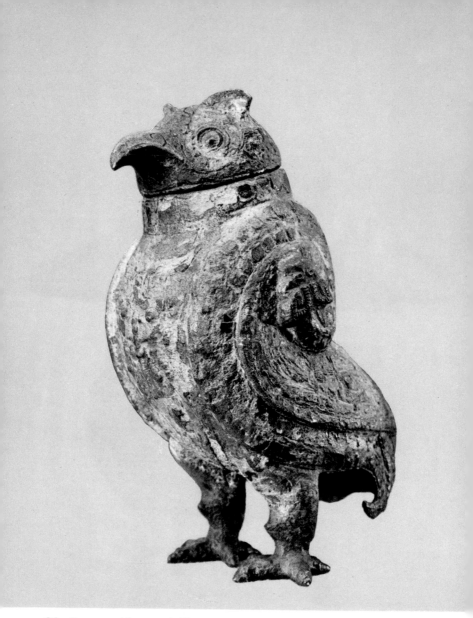

26. Zoomorphic vessel. Shang period. Freer Gallery of Art, Washington.

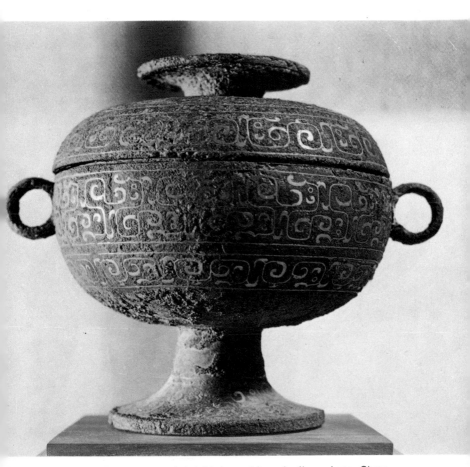

27. Bronze vessel inlaid in gold and silver. Late Chou.
Freer Gallery of Art, Washington.

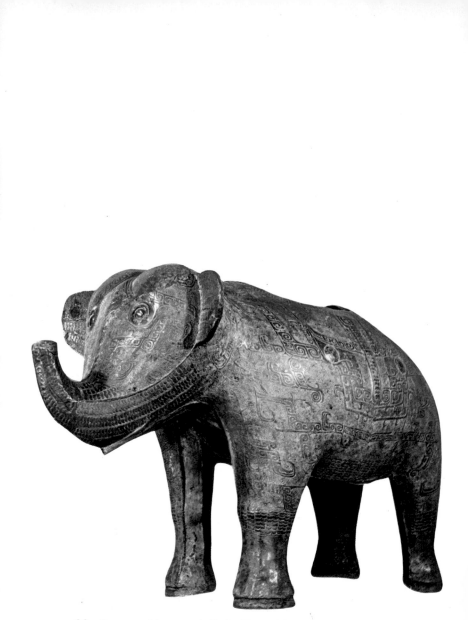

28. Zoomorphic vessel. Early Chou. Musée Guimet, Paris.

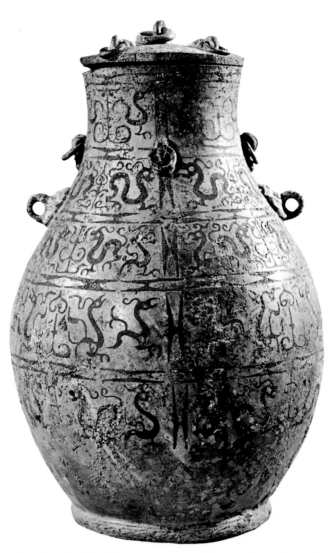

29. Vessel of inlaid bronze. Hu type. 'Warring States' period.
Vannotti Collection, Lugano.

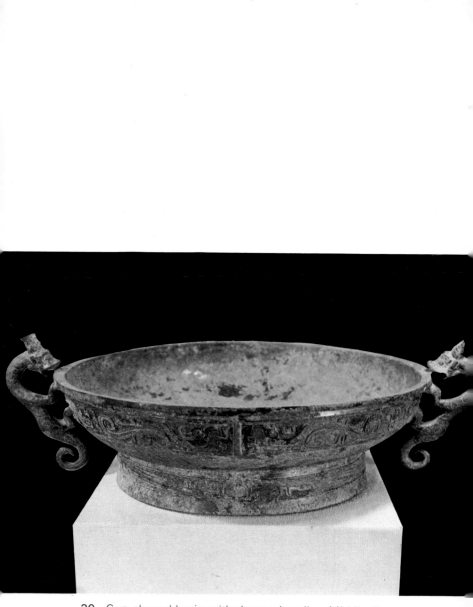

30. Cup-shaped basin with dragon handles. Middle Chou period. Musée Guimet, Paris.

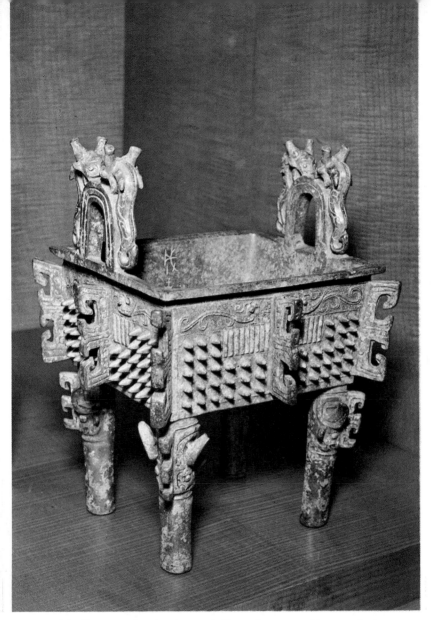

31. Rectangular ritual vessel. Fang ting type. Chou period.
W. Rockhill Nelson Gallery of Art, Kansas City.

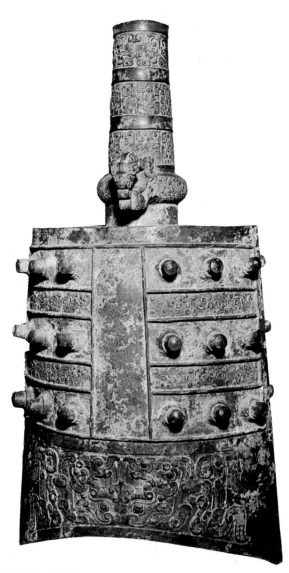

32. Bell with decorated handle. Chung type. Early Chou.
W. Rockhill Nelson Gallery of Art, Kansas City.

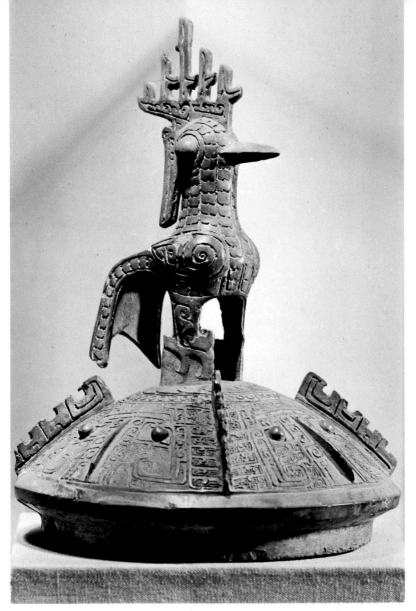

33. Round vessel lid. Early Chou. Musée Guimet, Paris.

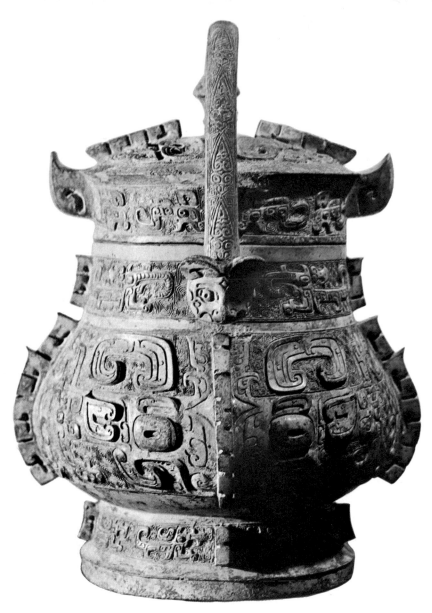

34. Vessel with hinged handle. Yü type. Early Chou. Freer Gallery of Art, Washington.

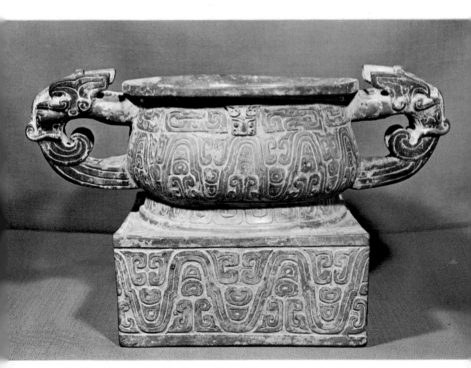

35. Bronze basin. Early Chou. Musée Cernuschi, Paris.

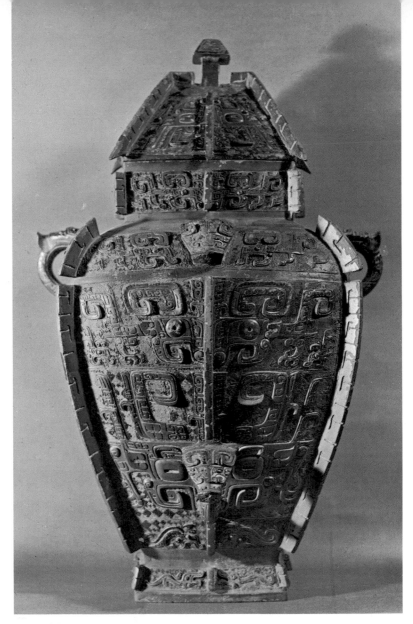

36. Wine vessel. Lei type with T'ao-t'ieh decoration. Early Chou. Nezu Art Museum, Tokyo.

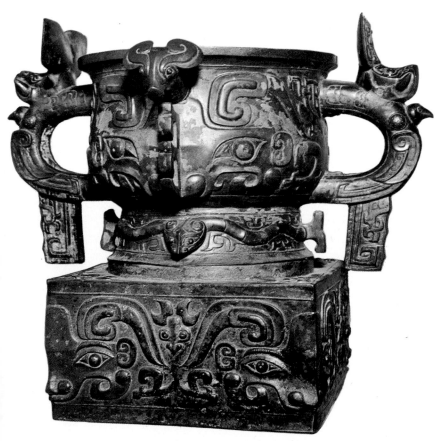

37. Ritual bronze basin. Kuei type. Early Chou. W. Rockhill
Nelson Gallery of Art, Kansas City.

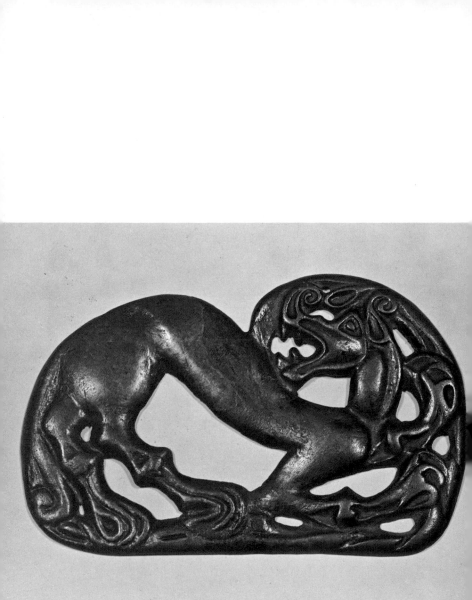

38. Bronze ornament. Stylised carnivorous animal with head turned. Ordos art. British Museum, London.

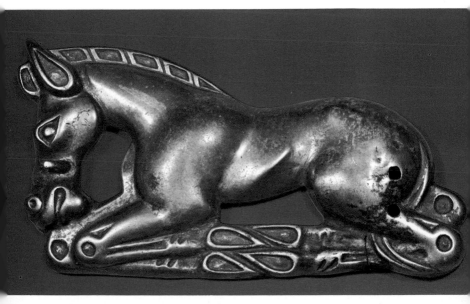

39. Ornamental silver plaque of a mule or wild ass. Ordos art.
British Museum, London.

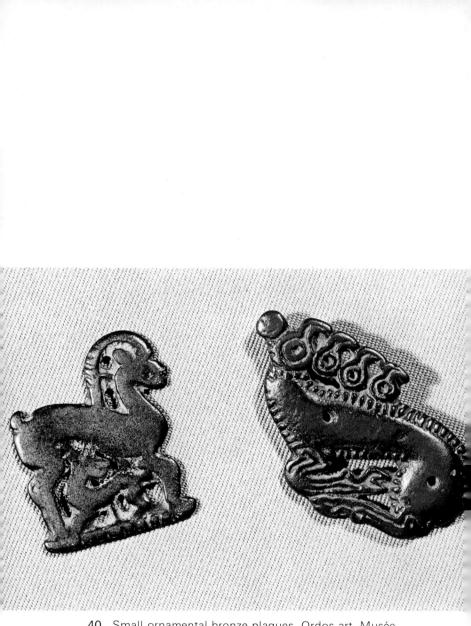

40. Small ornamental bronze plaques. Ordos art. Musée Cernuschi, Paris.

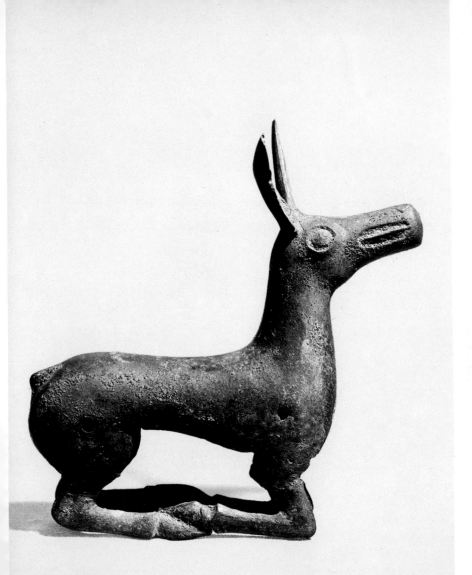

41. Deer at full gallop. Ordos art. Musée Cernuschi, Paris.

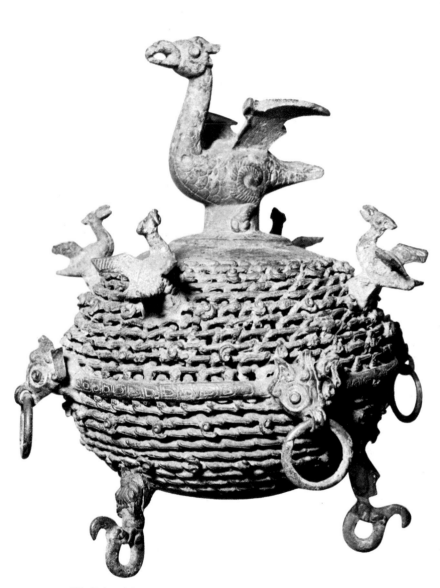

42. Tripod incense burner. Chou period. Metropolitan Museum of Art, New York.

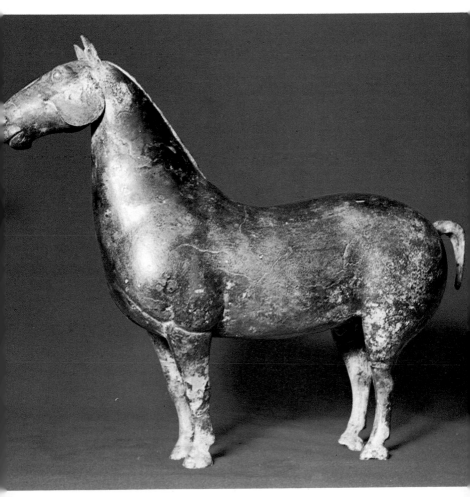

43. Central Asian bronze horse. Early Chou. W. Rockhill
Nelson Gallery of Art, Kansas City.

45. Figure, perhaps female (a bird trainer?). Late Chou
Museum of Fine Arts, Boston

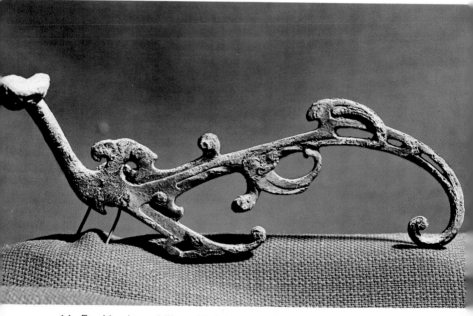

44. Buckle shaped like a bird. Han period. Musée Cernuschi, Paris.

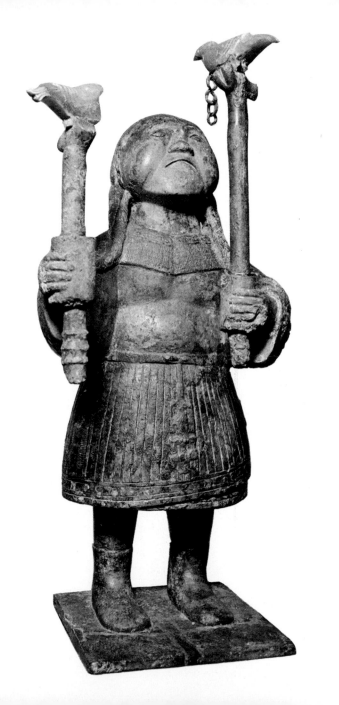

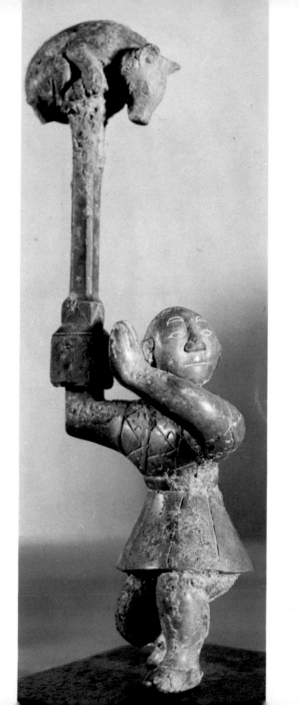

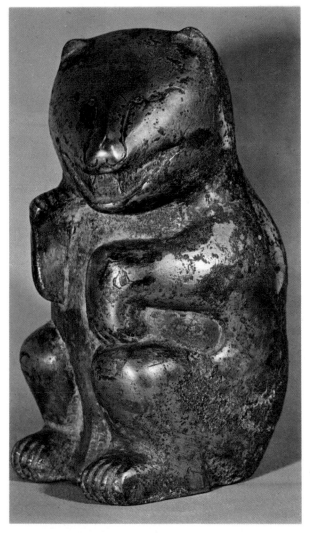

47. Bronze support in the form of a bear. Han period. British Museum, London.

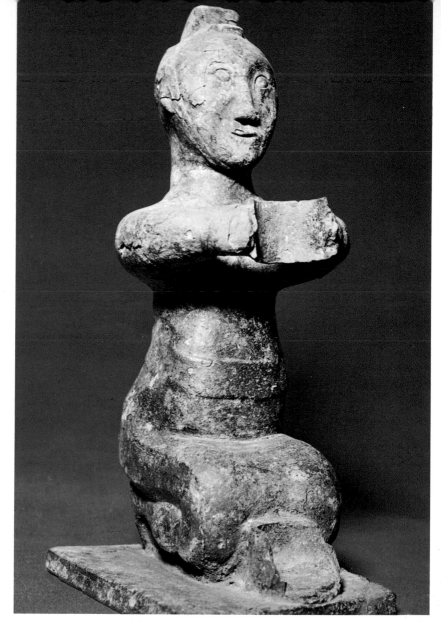

48. Bronze kneeling figure making an offering. Late Chou.
W. Rockhill Nelson Gallery of Art, Kansas City.

At the same time it modified fashion—as well as taste—which was conditioned by the extensive contacts which the Chou dynasties maintained with the 'barbarian' world of the West, which now, given the precarious political balance of power in Eastern Asia, could no longer be neglected.

For the rest, contact, or rather encounters, with the West played an important part in the diminution of the Chou Kingdom, and as a result of the Pontine Migrations brought to the frontiers of China characteristics originating in far away regions. Such characteristics are surprisingly close to our own, because their bearers were the Thracians and Cimmerians, peoples who originated as far away as the Dalmatian region. The presence of nomads on the frontiers is a fact which should not be overlooked. For a duel which lasted for centuries now began between the agricultural and sedentary peoples of the Chinese world and the nomadic hordes, which survive on a highly specialised economy which forces them to accept a view of the world and of life which is almost inconceivable for sedentary people. This duel ended in a definite victory for the sedentary peoples only in relatively recent times and after varying fortunes. Even variations in the shapes of vessels can probably be attributed to a change in taste partly caused by the influence of Western peoples. The widespread use of spheroid or ellipsoid forms resting on a flared base (the 'Tu'), whatever their origins, nonetheless express a natively Chinese taste. But the greater use of swelling vessels with a wide high neck

(whether with a square or a rounded base) could have been suggested by the terracottas from Altai or Ordos. And the ornamental use of figures of animals in relief on the sides of the vessels, some of them a reproduction of figures which functioned as containers, undoubtedly shows that the China of the Chou people acquired an element of maturity from the nomad world. The representation of animals was originally charged with symbolic values and linked with magic preparation for the hunt. An animal may be represented as posed and immobile, rigid with a heavy monumentality, or in movement or perhaps contorted in mortal combat, gripping an adversary; in every case it is—at least in the first phase—the dominant and sole motif of the art of the steppes, which is therefore called 'animalistic' art. The dominance of animal images reflects the specialisation of nomadic life: for breeders, animals are either the source of wealth or an insidious threat to the survival of flocks or herds. It follows, therefore, that there is a symbolism imposed on the animal images which often outlines the division of natural forces on three separate levels, all expressed as realistic images. The fecundity and fertility of the earth are expressed by herbivorous animals; these are dominated, subjugated and destroyed by negative and devouring forces, represented by beasts of prey; and these are themselves subjected to a sanguinary dependence on the forces of the 'powers above' or heavenly forces, represented by the eagle. This is expressed in the 'plaque of the struggle', which generally shows a

herbivorous animal killed by a carnivorous one that has attacked it. Apart from the meanings associated with the magic of the hunt and of omens, this composition expresses the essence of life itself: the eternal struggle between living things (herbivorous animals) and destructive forces (wild beasts) which triumph over the individual but which are themselves subject to decay and death, and are under the control of heavenly powers. The power of animal images was inevitable in a world such as this—permeated by a magic atmosphere of extraordinary amplitude and importance, under the authority of wizards (the shamans) who were ultimately responsible for the psychological integrity of the human groups who believed in them, and closely linked with the technical knowledge of metallurgy and the mysterious significance of animal beings which were able to act on men by magic. And all the more so since the life of the nomads was closely linked to that of animals: to the animals which they reared; to the horse—an indispensable means of transport without which it was impossible to organise a sufficiently ample and productive pastoral life; to wild game, which served as an occasional addition to the nomad's diet; and to beasts of prey, which were doubly dangerous as destroyers of livestock and enemies of man. For this reason even China, which had itself developed a symbolism based on images of animals, real or fantastic, was influenced by the artifacts and symbolism of the nomads, although the Chinese nearly always reduced them to decorative motifs,

retaining their aesthetic properties but rejecting their religious implications.

But there also arose, during the Chou period, a clear awareness of man's place in the universe, a new sense of the organisation and culture which Chinese civilisation had assumed, and an interest in a wider life. This led bronze workers and founders to depict the human being for his own sake, without symbolic or religious implications but simply as a study of a characteristic type (foreign or Chinese) or as a special subject for genre scenes. The juggler with a bear is an example of these works, reflecting not only a remarkable change in taste but also a completely different appreciation of works of art, which now broke away—very slowly—from the magic and ritual forms of preceding ages. This interest in foreign peoples and decorative values resulted in the introduction of objects hitherto unknown, from the creative repertoire of the nomads into Chinese work of the late Chou period, that is, the period of the 'Warring States' and of the Han epoch. These objects, hooks, buckles, ornamental buttons and pins, reveal the existence of a substantial common denominator of taste among nomads and sedentary peoples, and undoubtedly prove that nomadic customs and practices had infiltrated Chinese culture in strength. There are several reasons for this. To the increased volume of commercial traffic (not yet organised on a vast scale but certainly noteworthy) must be added technical influences of a military character. By comparison with the highly mobile cavalry of the Western

barbarians the war chariot was an obsolete piece of equipment, especially for use in numbers. In China, dress and weapons were modified as a direct result of the triumphant spread of the use of cavalry: the cavalryman had to be able to move freely in his clothes and his weapons had to change. Those used for close combat (beginning with the Ko) were abandoned, being replaced by the lance—long but not too much so—the double bladed sword with blades suitable for striking from a horse, and short, powerful daggers for the last desperate defence. Hooks and ornamental buttons for belts were in widespread use, especially from the beginning of the 4th century, but some of these continued into the middle of the 1st millennium BC. Their western origin seems to be confirmed by two widely used names which are undoubtedly of Indo-European derivation and which come from Central Asia: 'hsi-p'i', which corresponds to the ancient *serbi* or *sarbi* for 'hook', like the Greek ἅρπη and is the transcription of a word which has the same root; on the other hand 'kuo-lo', which in ancient times was pronounced 'kwak-glak', corresponds to the 'kukal' of the Central Asian language called Agni; it means circle or buckle, and is derived from the same root as the Greek κύκλος ('circle'). The principality of Chao, which dominated a large part of the north, probably introduced this foreign terminology. (It was derived from the peoples of Central Asia and transmitted through the peoples of Ordos.) The principality was almost an independent kingdom, and in the reign of Wu-ling

(325–239 BC) developed fighting tactics characteristic of the nomads, and also adopted the same dress and weapons.

Buckles, hooks and clasps also rapidly became objects which were worked with the greatest care. The decoration, which is nearly always based on animal motifs while retaining a geometrical patterning, is on the whole very fine. Inlaid work is used copiously, and the settings in precious and semi-precious stones reveal a well-developed taste for the colour effects which the inlays and settings produce. But in no case does the decoration, however rich, change the functional purpose of the object. Perforated buckles are often enriched by their settings or by filigree work; these achieve a quite extraordinary effect and show the artist's interest in decorative form. Tigers, serpents, dragons, fantastic animals, stylised birds, animal creatures with four bodies and one head make up the repertoire of the artists, who very often manage to turn these objects into veritable jewels. Sometimes it is possible to identify wooden prototypes which connect forms created in bronze—or at least the characteristic decoration of bronzes—with the Altai region, linking them with the work done in Pazyryk. Monstrous masks, profiles of stylised animals, fantastic compositions inspired by a decorative feeling which is almost abstract, complete the rich series of ornamental motifs most widely used. But it should not be forgotten that hooks and buckles with decorative subjects inspired by the life and society of the Chinese

people are still found, although more rarely in later times (that is, between the first century BC and the first century AD under total Han domination). In particular, there are players of lutes or other stringed instruments, sailors with oars, and acrobats. The style remains the same but the decorative subject changes, in the search for a new form of powerfully stylised and completely Chinese expression—which became established towards the end of the Han period.

Less clearly separated from the nomadic works are the plaque decorations for horses' harnesses. The ubiquity of the unmistakable Central Asian style, with all its iconographic and decorative conventions, makes it difficult to distinguish the authentically Chinese work—especially the very ornate work of the northern provinces—from that of Ordos and the Eastern Siberian region and that of Central Asia. Both the subjects (above all the deer and goats and even the felines and eagles' heads which are stylised in the Altaic manner) and the quality of the work—which is, with rare exceptions, mediocre—contribute to this difficulty. Bronze decorations for horses' harnesses seem to be almost international in style, and their homogeneity is fostered by the phenomenon of cultural and stylistic interchange. The outstanding example is the progressive absorption of Chinese culture by the Hsiung-nu hordes (sometimes mistakenly thought of as the models for Attila's Huns), who were the first of the great barbarian empires, and ferocious and fearsome adversaries of Han China.

During the Han period existing forms and styles underwent profound changes. There was a complicated process of development from which sprang the main premises of Chinese aesthetics and criticism. Nearly all previous works were now surpassed as new values were established and new concepts of composition imposed rhythms which almost belong to dancing on the images used before. New and lasting plastic conventions came into existence, and called the artist's attention to subjects until then unknown or neglected. As a result of the spread of Taoist doctrines, a strong and austere naturalism became fundamental in Chinese figurative work in all the arts. Vessels assume the slightly stylised form of animals and of fantastic creatures; the fantastic element, however, appears only in the addition of one feature to a real animal (for example, the single horn of the unicorn) or in their symbolic decoration with inlaid work.

Many of the traditional vessel forms, moreover, disappeared and were replaced by others, some of the amphora form, others of a new type which bear, on the complicated and heavy decoration of the lid, symbolic forms and meanings derived from Taoist doctrines. Exact and admirable copies of these vases or incense burners were made in fine terracottas which are conventionally named 'proto-porcelain'. Their derivation from works in bronze is attested by, among other things, the blue-green glaze which covers them and which imitates, after a fashion, the colour of the bronze patina.

MIRRORS

In Chinese bronze production there is a special place for mirrors, which are of varying importance and dimensions, but always round, with one side perfectly polished and perhaps silvered over to improve the reflection and the other worked with decorative and symbolic motifs in relief. A button-shaped bulge in the centre of this side was perforated, allowing a piece of cord or leather to be threaded through it in order to make the mirror easier to handle. It is thought that Chinese mirrors derive ultimately from Greece, and that they reached the Far East by indirect commercial contact (through the Scythians) with the peoples of the steppes or other makers, thence entering the sphere of influence of the Achaemenian culture, which spread to the nomadic concentrations on the coast of the Aral sea and to the groups established on the Altaic range. But some examples are certainly earlier than the 5th and 4th centuries BC, the period when these objects are most strongly in evidence; so that the theory does not seem tenable in its present form.

The most archaic form of mirror without a handle is sometimes square and sometimes round. They are all made of two superimposed sheets of metal. One, the base for the reflecting face, is often worked on the reverse side or pierced through like a buckle. It is often decorated with a stone setting, especially with turquoise. The two sheets are welded together but the presence of circular ornaments is a survival

from an older phase when the reflecting side of the mirror was nailed to the back. The decoration of the back varies according to the period in which it was executed. In the first phase the dominant motif was composed of small interlocked figures of dragons, or of four larger dragon forms, or of serpents introduced into a background of spirals and a granulated motif. This was followed by a period of extraordinary variety in decoration, all of it pervaded by religious and magic symbolism—for the mirror is also an amulet and a magic token. This is stated by Ko Kung, in his work *Pao-p'u-tzŭ* ('The Master Who Has Embraced Simplicity'). 'The spirits of the primordial elements of creation are all able to assume human form and to deceive the eyes of man with illusions. . . . But they cannot change their shape in a mirror. This is why the Tao masters of ancient times, when they retired into the mountains, carried a mirror nine ts'un in diameter or even larger on their backs.' There is a mirror in the British Museum which bears a long inscription. After stating that it is an object worthy of the emperor, made according to the best techniques and of the finest metals, it says, among other things, 'To the left a dragon and to the right a tigress drive off evil influences. The red bird and the black warrior harmonise the yin and yang [the opposites]. May sons and grandsons be protected by you and may you be able to occupy the centre and give long life to the parents. May your longevity be equal to that of the stone or metal and your life like that of the sovereigns and nobles.' Out of these complex beliefs

arose a special decorative motif called the T form and its variations the TL and TLV. These symbols have more or less the form of capital letters of the Latin alphabet as shown above (the V is a right angle) but they are drawn slantingly. All of them express the relationship between sky and earth and describe the strange relationships between the mysterious forces which control the world, ordering them in a manner likely to favour the owner of the mirror. The precise meaning of these signs is elusive: they undoubtedly belong to an esoteric language, very likely inspired by alchemy; but the key to them is lost. (Taoism developed a science of alchemy which is similar in aims and techniques to that of the West.) Thus the back of the mirror becomes a magic surface not very different from the 'mandala' (the word means circle) of India, on which are inscribed meditative exercises which would help the devout to rise above the illusions of the world and open the way to achieving enlightenment. The Chinese mirror remains, however, rather an amulet or talisman, even though it sometimes carries the images of the animals who preside over the cardinal points (expressing astronomical and astrological knowledge), and at other times figures derived from the cult of Tao.

Different centres of production, often widely separated geographically, functioned in different periods. The usurper Wang Mang (AD 9–23), a talented man and a passionate student of Taoist astrology and alchemy, did not hesitate to set up a mirror factory in which—with special magic rites—

new and even more miraculous virtues were bestowed on the mirrors. Subsequently their aesthetic qualities assumed a remarkable importance. The craftsmen of the period of the 'Warring States' had given the stylised images of animals on the backs of mirrors an overall composition, which suggested a vortex in continual motion (Chinese antiquarians later called this 'the vertigo of flight'), and which was able to awake echoes at a much later time. Those of the Han period, on the other hand, concentrated on static animal symbols which were connected with the cardinal points and with astrological dates; and all the decoration, which is very stylised and fine, tended to fall in concentric areas. At the beginning of the period of the Three Kingdoms and Six Dynasties (AD 220–589) a fantastic animal of vaguely leonine aspect—but with a horn—began to appear on mirrors. The horn derived from the horned lion motif of Iran (which is also found in India), but it is possible that it may originate in a memory of the T'ao-t'ieh. These figures, which are connected with Taoist magic, take the name of 'Pi-hsieh', or 'exorcism of magic'— in other words, good luck charms. Towards the end of the Six Dynasties or at the very beginning of the Sui dynasty (and therefore in about the decade from 585 to 595) mirrors are decorated with a motif of a real though stylised lion—or rather lions, since there are at least four on every specimen. The motif is like an echo of a well-known musical and choreographic spectacle which expressed complex symbolic values and was entitled 'Dance of the lions of the five

spatial directions' (a title which still survives in an abbreviated and simpler form; its companion-piece, 'Melody of Universal Peace', is also suggested. The 'Dance of the lions', which reflected some of the Indo-Iranian cosmology, was performed in China for the first time in AD 577 by a group of acrobats and a big orchestra from Kush (a large city on the caravan route in Central Asia, famous for its musicians and its corps de ballet). The five simulated lions played the leading roles and were painted in various symbolic colours: black for the north, blue for the east, red for the south, white for the west and yellow for the centre. Each lion was animated by twelve acrobats. The evolution of this entertainment, which was repeated an infinite number of times, was determined not only by its choreographic values but also by its magical and symbolic implications, which finally comprised an exact and universal relationship between the stylised images of the lions and the various spatial directions. The lions on the mirrors vary in number, according to whether the central point is among the cardinal points or whether the zenith and intermediate directions are included.

In the very late T'ang period (AD 618–907), that is to say in the 8th century, mirrors had become highly prized articles not only because they brought good luck—like wedding mirrors—and had other magical and symbolical functions, but also because they bore such delicate inlaid work and decoration in gold and silver. The variety of forms had increased adding to the circular shape others which were lobed,

star shaped or like stylised flowers. The meaning of the lion motif changed completely. The symbol of the grapevine and the grape was added to that of the beasts; this was an Iranian contribution, perhaps of Manichean origin, and expressed the desire for a mystical union with the heavens, hinting at life after death. The spatial symbolism disappeared and the number of beasts was fixed at seven (as in the mirror in the Vannotti collection), to refer specifically to the seven elements which constituted the cosmos and the seven heavenly lights (the five planets, the sun and the moon). Moreover, the metals used in the bronze alloys were always five in number, although not always the same five, and the number was probably chosen in homage to the symbolic value attached to the number 5 in the Manichean world. On other mirrors are found winged lions and horses, also of Iranian origin, together with the Chinese phoenix; elsewhere scenes of horsemen shooting with bows and arrows and on the point of trapping fleeing game are Chinese in atmosphere but are based on Iranian themes of the chase which decorate plates and silver cups. These works confirm that during the T'ang period in China trends in taste and fashion inspired by the Iranian world affected not only the decoration of silk but also the other minor arts.

INCENSE BURNERS

Incense burners, like mirrors, occupy a special place in Chinese bronze production because alongside

metal specimens are found others, of great value, in terracotta. The most characteristic form is one with a perforated conical lid, decorated with wavy lines or other ornamental motifs which—in a rather abstract manner—refer to the waters which surround the island of Po-shan (the Island of Blessed Immortals of Taoism) or the structure of this mythical and paradisial land. Some of the objects are of great value and variously decorated with inlays and settings (of precious or semi-precious stones), sometimes supported on a flared base and at other times by symbolic figures in the round. The aesthetic effect created by the holes through which the smoke issued was carefully and cleverly exploited in relation to the form and the decoration, the holes being either in full view or hidden between the waves of the symbolic water.

BUDDHIST IMAGES

The spread of Buddhism in China was a phenomenon of the first two centuries of our era brought about by Indian and Central Asian missionaries and by Prince Arsacidi of the reigning family of the Parthians. The first images appear almost furtively, without a clear iconographic meaning, on the backs of some mirrors which retain the linear stylisation and decoration of Han mirrors and belong to the 2nd and 3rd centuries.

Buddhism soon created a demand for images and edifying works so vast that it enormously increased

the activities of stone sculptors and bronze founders. Hence the votive steles, as well as those for worship, compositions which depict miracles or scenes of paradise (sometimes on a gigantic scale), and statuettes and small figures in bronze, either for altars or for votive purposes, the oldest of which has come to light being dated AD 338. The presence of the Wei people —of Turkish origin—in the northern regions of China greatly helped the spread of Buddhism: foreign dynasties were not tied to the Confucian tradition, and it was in their interest to develop a separate identity from that of the old Chinese world, which remained hostile and difficult to penetrate. It is during their dominion that Chinese Buddhist art becomes a plastic phenomenon of considerable importance. Wei Buddhas are clearly Chinese and very different from those of India or Central Asia, although in some of them it is possible to find clear traces of the 'semi-classical' Buddhas which were products of the artistic tradition called 'Greco-Buddhist'. (This made use of the Apollo image in order to confer on the Buddha himself the aspect and qualities of a divinity, making him different and superior to the human Teacher.) There are, however, quite a large number of other works which feature a type of image created by the school of Mathura, quite different from those of Gandhara, whose Hellenistic and Central Asian characteristics clearly indicate an Indian origin.

A long period of adjustment to local taste and religious thought now began: for the image of the Buddha was imbued with various conflicting ele-

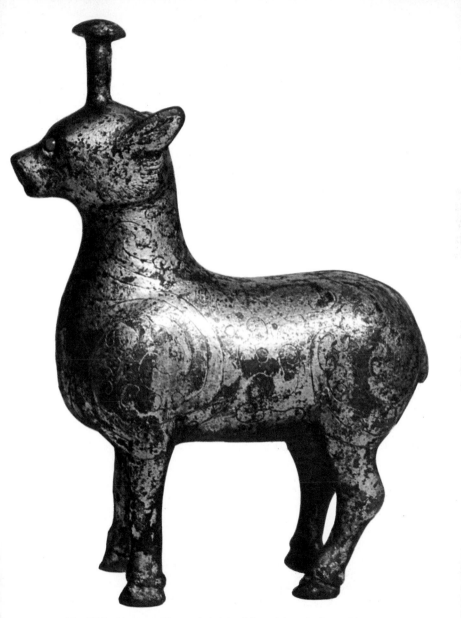

49. Gilded bronze figure inlaid with gold and silver. Han period. British Museum, London.

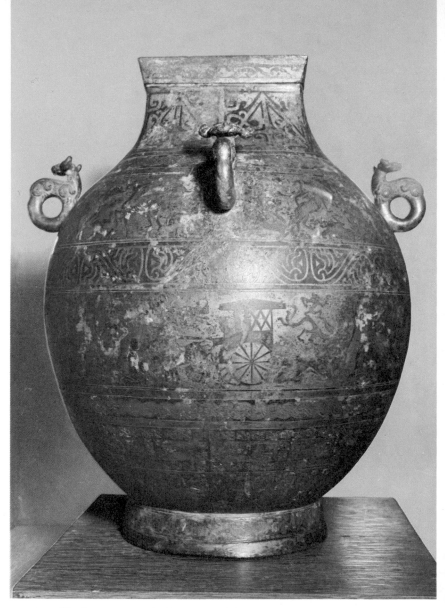

50. Bronze vessel. Hu type, inlaid with gold and silver. Early
Han: Museum of Fine Arts, Boston.

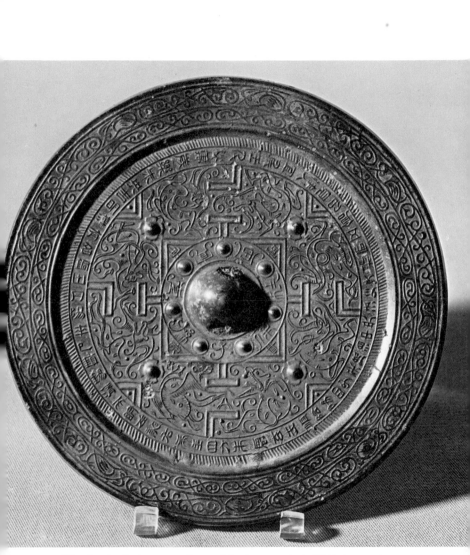

51. Back of a bronze mirror with characteristic TLV decoration.
Han period. Musée Cernuschi, Paris.

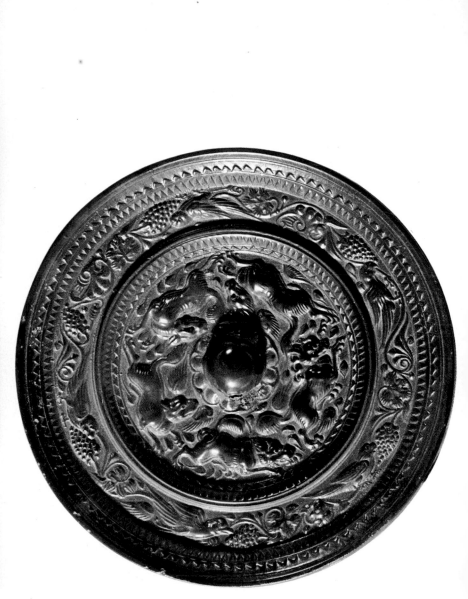

52. Back of a bronze mirror with relief decoration. T'ang
period. Musée Cernuschi, Paris.

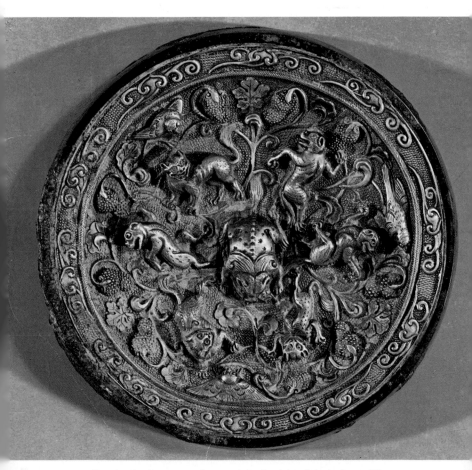

53. Back of a bronze mirror, plated with gilded silver. T'ang period. Vannotti Collection, Lugano.

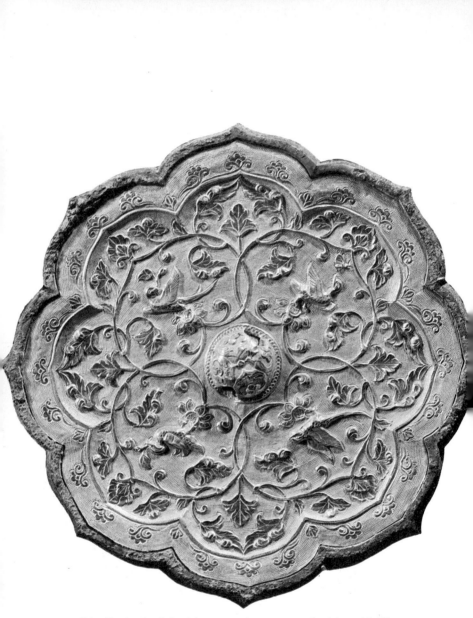

54. Back of a lobed bronze mirror covered with gold. T'ang period. Freer Gallery of Art, Washington.

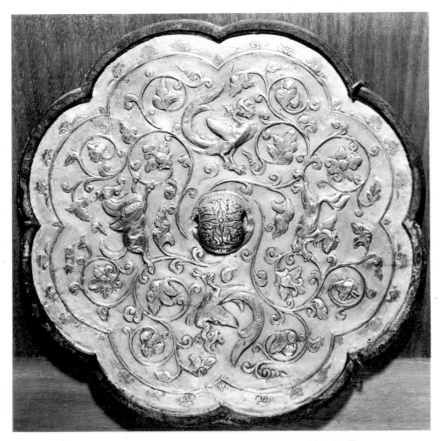

55. Back of a 'good luck' wedding mirror. Middle T'ang period. Freer Gallery of Art, Washington.

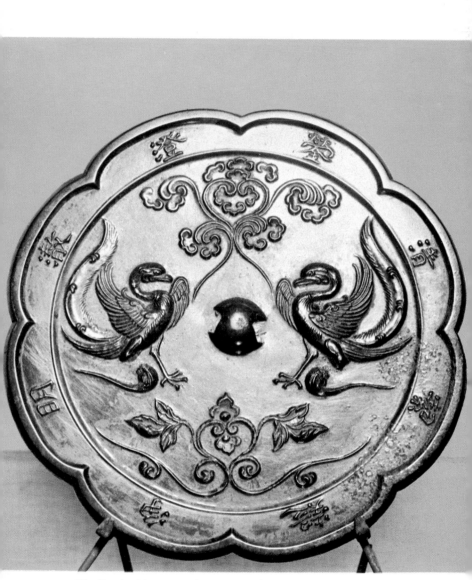

56. Back of bronze mirror covered with gold and silver. T'ang period. Metropolitan Museum of Art, New York.

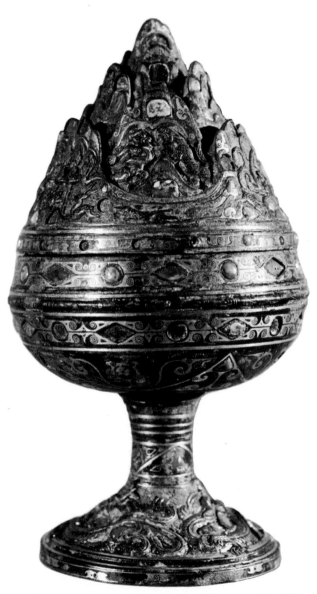

57. Goblet-shaped incense burner. Han or earlier. Freer Gallery of Art, Washington.

58. Buddha, perhaps Maitreya. Six dynasties period,
Northern Wei. Metropolitan Museum of Art, New York.

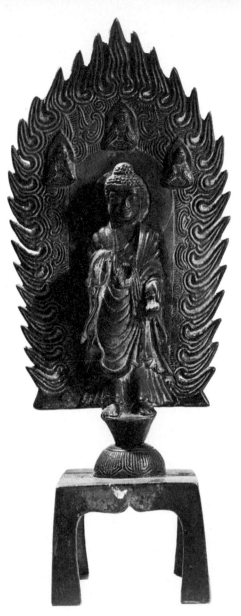

59. Statuette of the Maitreya cult. AD 531. Private collection, Prague.

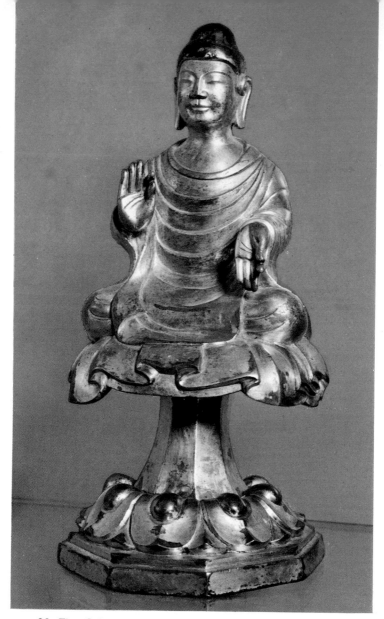

60. The Sakyamuni Buddha. Northern Ch'i dynasty. W.
Rockhill Nelson Gallery of Art, Kansas City.

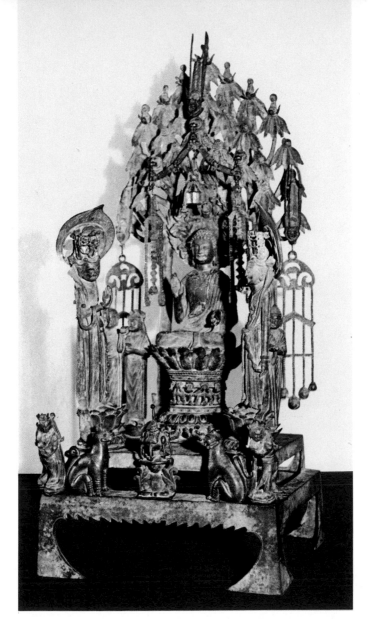

61. Bronze altarpiece. AD 593. Museum of Fine Arts, Boston.

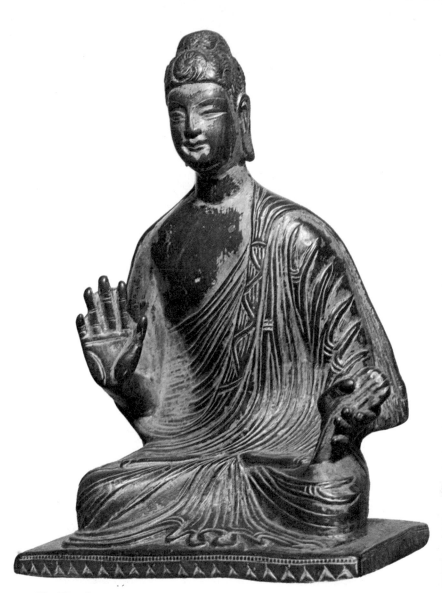

62. The Sakyamuni Buddha, making the gesture of reassurance. Northern Wei. W. Rockhill Nelson Gallery of Arts, Kansas City.

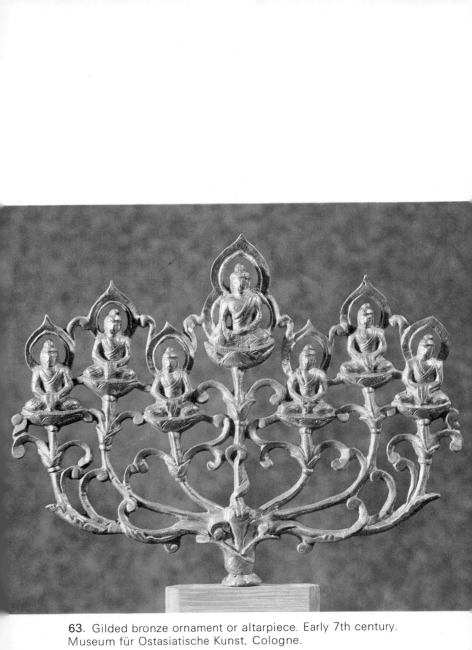

63. Gilded bronze ornament or altarpiece. Early 7th century.
Museum für Ostasiatische Kunst, Cologne.

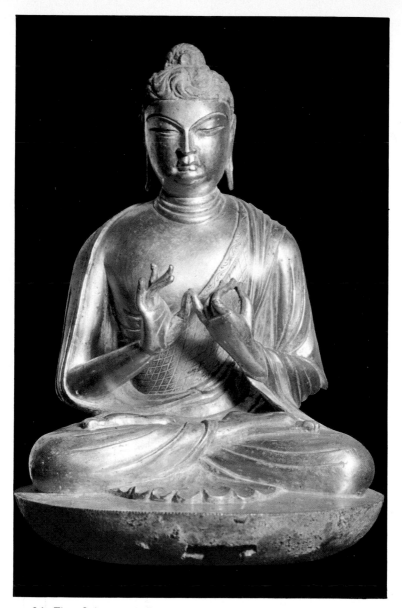

64. The Sakyamuni Buddha seated on a lotus. Gilded bronze. T'ang period. Metropolitan Museum of Art, New York.

ments and originated in a world which was from the social point of view completely different from that of the Chinese. The Wei bronze statuettes, as well as the stone images, assume elongated stylised forms, comparable to our Gothic style. Their upward tendency, which we shall also find in later periods, grows out of almond-shaped haloes which express complex thoughts about the nature of light and the magic properties of flames, out of the structure of the face and of hair styles (often symbolic), and out of draperies in motion. Cleverly combined, these elements bring together such a quantity of symbolic meanings that, were it not for the harmony of style achieved, they would look like complicated diagrams of religious ideas which only the initiated could understand rather than works of art. Instead they are often exquisite plastic works of very high quality, and remain one of the expressions of Chinese artistic genius most easily appreciated by Westerners, if only for the mystical feeling they convey, which has an affinity with the spirit of the Medieval period in the West.

It would be pleasant to establish an exact relationship between this work (which was not restricted only to the Wei period) and medieval iconography. But in fact this similarity, which has given critics much food for thought, is so vague and nebulous that it can only be considered purely fortuitous and coincidental. It is, above all, the incisive style of the bronzes together with their tendency towards ornateness (without interpreting this in a pejorative

or limiting sense) which makes them particularly admirable.

The favourite subjects of the Chinese bronze workers, from the beginning of the Wei period, are the forms of the Buddha: for example Sakyamuni (the historic Buddha) and Prabhutaratna (one of the Buddhas of the past), which embody the idea of the continuity of Buddhist law; the Bodhisattva Maitreya, who will become the Buddha of the future and who, when the world has been saturated with evil, will restore the kingdom of the law; Amitabha-Amitayus, the supreme Buddha of light and eternal life, and his spirit Avalokitesvara, who in China, curiously enough, became a female divinity, Kuan-yin, embodying Buddha's compassion for all living things. Naturally, which of these was chosen was not arbitrary: it depended on the fortunes of the different sects and schools in China. Predominant among these were the 'Ching t'u tsung', the school of the Pure Earth (the Buddhist Paradise), which teaches the resurrection of the faithful in the Western paradise where Amitabha the 'T'ien Tai Tsung' reigns; and a purely Chinese school which affirmed that all creatures were equal to the Buddha since they were made of the same substance. And there were others. All of them taught in one way or another that intensity of faith and pure devotion could save the faithful in any circumstances, however great the burden of acts done in this life or the preceding one.

Apart from decoration connected with Chinese Buddhism, it is evident in bronze objects—whether

votive or cultural—that the Chinese liked for their own sake the effects which could be achieved by working the metal. The dedicatory compositions of the Sui epoch, for example, instead of exaggerating the length of the figures which surround the central figure, close it in with a profusion of lotus flowers as delicate as a piece of lace, while the elaborately worked corolla of other lotus flowers supports it, employing symbols expressive of a mental or spiritual state. The hard- and sharp-edged drapery of the first Wei gives way to another form, still as strongly stylised but more balanced and less aggressive. This is the Indian style of the Gupta period or rather the international trend towards a figurative art which derived from it and caused the change in style. It is seen in the growing tendency to make dresses cling to the body and to bunch the folds of the drapery together for decorative effect in a manner which suggests clothes that are soaked. In some cases, however, the stylised representation of the folds gives rise to new conventions which have the feeling and power of abstractions, as in the Wei Sakyamuni in Kansas City. In general, however, artistic evolution entailed a gradual return to a less conceptual and more realistic plastic convention. For example the faces of images tended to lose their characteristic length and become round, very probably under the inhibiting influences of Gandhara culture (the second phase, works in plaster) or the Kashmir terracottas which represent the last but still powerful expression of the encounter between Classicism and Buddhism

(and at the same time contain vivid references to the best Gupta works). Thus in the T'ang period we have images which are inspired completely by the Gandhara culture; though the lengthening of the hands, the lightness of the gestures and the harmonious disposition of the folds appear to be of Chinese inspiration, they developed out of Central Asian influences, even in paintings. The decorative value of the works gives way to more substantial form and symbolic elements diminish in number. The statue now speaks for itself; and it is indicative that Chinese Buddhist art managed to imprint on the Buddha's image, by means of style itself, a transcendent quality expressed through the human form which seems to embody the quintessence of the universe; an apparently inexpressible concept unless described with the help of a complex symbolism.

Above all, it is the faces of the bronze Buddhas of the T'ang period, with their new expressiveness, with that inward splendour which does not depend on the gilding alone, with their serenity and their inner life, that transmit the unyielding character of beings who have finally and decisively freed themselves from worldly illusions.

LIST OF ILLUSTRATIONS

1. Ritual vessel with a spout, and a lid with a human face. Ho type. Late Shang period or early Chou (12th–11th centuries BC). Freer Gallery of Art, Washington. The loops, to which the lost handle was attached, form the ears: the horns are those of male Muntjak sheep. This is undoubtedly a mythical being whose power was associated with the rituals for which the vessel was used. Note the precise, detailed decoration on the body.

2. Chalice for libations and for wine tasting. Ku type, from Anyang. Shang period (13th–12th centuries BC). W. Rockhill Nelson Gallery of Art, Kansas City. The slim campanula form and the ribbing which adorns it recall the corolla of a flower. On the base and halfway up the stem there are T'ao-t'ieh motifs.

3. Spiral ornament with a dragon's head and neck. Middle Chou (10th–8th centuries BC). W. Rockhill Nelson Gallery of Art, Kansas City. On the neck of the monster there is a turning motif of square spirals: they both enclose and complete the stylised image of the dragon. It may have been designed for furniture.

4. Table leg or bronze support in the shape of a part-animal being: probably a demon. Late Chou (5th–3rd centuries BC). W. Rockhill Nelson Gallery of Art, Kansas City. The figure is decorated with inlaid gold and silver. This technique diminishes the quite extraordinary plastic power of this figure, making it more decorative.

5. Bronze container. Chih type. Badalich Collection, Milan. The simple, elegant form seems to be linked to the ceramics and porcelain of previous periods. Light-coloured bronze with traces of gilding. Two strips of geometrical decoration.

6. Dress ornament in the form of a stylised dragon. Late Chou. W. Rockhill Nelson Gallery of Art, Kansas City. The likeness is expressed extremely decoratively by the stylised, ribbonlike form, which, although not exclusively Chinese, assumes in China an original and truly autonomous appearance. Gilded bronze.

7. Vessel in the form of a stylised cock, on a round base. Early Ming dynasty (end of the 14th century AD). British Museum, London. Taste for works in bronze varied across the centuries, but the stylisation of animals demonstrates that the technical ability and the precision of Chinese artists did not diminish.

8. Tripod vessel. Ting type, with approximately semi-spherical bowl and looped handles. Late Shang (13th century BC). Academy of Arts, Honolulu. In this specimen a decorative frieze, which echoes the design on the legs, has the T'ao-t'ieh motif. The legs resemble stylised dragons' bodies.

9. Tripod vessel with hollow legs and trilobate body called
'Li' or, also, 'Li-eing'. Shang period. Musée Guimet, Paris. On
each lobe there is an image of a leonine T'ao-t'ieh, with big
spiral horns, which seizes between its jaws (here the monster
also has a lower jaw) the cylindrical leg of the vessel.

10. Bronze vessel of rectangular type with looped handles
(Ting type, rectangular and with four legs). From Anyang.
Shang period. W. Rockhill Nelson Gallery of Art, Kansas City.
This was used to cook meals during the sacrifices. On the
broadest side there is a stylised T'ao-t'ieh image and above,
on a smaller scale, two dragons face each other.

11. Wine vessel. Yü type, complete with lid and hinged
handle. End of the 11th and beginning of the 10th century BC.
W. Rockhill Nelson Gallery of Art, Kansas City. The tall
graceful shape of the vessel and the detailed decoration
suggest that it belongs to the early Chou period.

12. Ritual water vessel decorated with a Lei-wen frieze. Late
Shang period or early Chou. Musée Guimet, Paris. On the
frieze which runs along the rim are depicted stylised cicada
larvae, symbols of life and resurrection, in groups of three. On
the strip round the base, round motifs with sections of spirals
alternate with stylised eyes: the whole may originate from
solar symbols.

13. Wine vessel. Yü type, with lid and hinged handle. Middle Chou. Museum of Fine Arts, Boston. The powerfully stylised decoration and the uncompromising projection of the animal images on the sides of the vessel reveal clearly the change of taste under the Chou, which now developed a baroque heaviness.

14. Bronze Chüeh for libations of warm wine. Late Shang period. Freer Gallery of Art, Washington. The vessel shows the characteristic columns which spring from the rim, which is supported here by the horns of Muntjak sheep. The decoration of the sides is made up of grape motifs and the ubiquitous image of the T'ao-t'ieh. The legs of the tripod are shaped in a manner which makes them part of the decorative motif.

15. Tripod vessel of the Chia type, with ribs and looped handle. Shang period. W. Rockhill Nelson Gallery of Art, Kansas City. This form, although much less elaborate and complex than the Chüeh, is considered particularly suitable for warming wine.

16. Bronze vessel of the Chia type, with four legs, a lid, ribs, an animal figure on the lid and a looped handle. Shang period. British Museum, London. Vessels of this type with four legs are very rare, appear much more squat from a visual and aesthetic point of view, and are less functional from a practical one. Here the body of the vessel is shaped in a manner to make the whole more pleasant to look at.

17. Vessel of the Ho type for warming wine, with four legs and a spout on the lid. Late Shang period or early Chou. Nezu Art Museum, Tokyo. The decoration, in strong relief, is made up of animal motifs and of grotesque human masks with goat horns which represent the T'ao-t'ieh motif accurately, but with a completely different symbolic meaning.

18. Wine vessel of the Kuang type with hinged lid decorated with a fantastic animal head. Shang period. Freer Gallery of Art, Washington. The heavy form of the Kuang type, similar to our sauce boats, becomes almost zoomorphic in the upper section when treated in this manner. The relief decoration is pronounced, and based on T'ao-t'ieh masks.

19. Hand axe. Ko type. Shang period. Vannotti Collection, Lugano. On the haft, which can be fitted into a handle, there is a small hare, stamped by heat, which is depicted with great vivacity. On the blade is a cicada larva encrusted with a knob of malachite.

20. Large wine cup. Chih type. Shang period. Vannotti Collection, Lugano. Although heavier and more elongated, this resembles the Ku form, as can be clearly seen in the flared rim, the decoration at the top (based on a bunch of grapes), and the swelling of the middle part of the body, which is supported by a base cast in the shape of a ring.

21. Wine vessel. Tsun type. Shang period. Metropolitan Museum of Art, New York. Rogers fund, 1943. This form too is related to the Ku type but is more squat and of greater volume. The decoration, using small dragons and large incised T'ao-t'ieh, is interesting.

22. Pair of curved knives with rows of animals on the handles. Ordos art, (between the 6th and 1st centuries BC). Musée Cernuschi, Paris. As they come from the Ordos, a region under Chinese influence, they are no doubt inspired by the art of Tagar (Siberia); this is particularly evident in the decoration.

23. Bronze axe head with a hollow projection for fitting the handle. Shang period. Musée Guimet, Paris. The decoration, based on the larva of a cicada, makes it fairly certain that this is a ritual axe, although its size and weight do not rule out a more practical use. It comes from Honan.

24. Urn or vessel of the Yü type, with hinged handle and a lid. Shang period. Musée Cernuschi, Paris. Except for the man, who has two snakes on his thighs, the whole composition is made up of various animals. The vessel deserves attention because of its remarkable plastic vitality. There is an identical copy in the Sumitomo Collection.

25. Wine vessel composed of the foreparts of two sheep, which support the large central mouth. Early Chou (11th century BC). Nezu Art Museum, Tokyo. The fleece of the sheep is, in this case, stylised, with a network of square scales: on the shoulders there are spiral motifs, related perhaps to the rotating motifs of Iranian bronzes and jewellery. This type of vessel, which is characteristic of the Chou period, is called a 'Tsun'. The T'ao-t'ieh and dragon motifs are present.

26. Zoomorphic vessel. Shang period. Freer Gallery of Art, Washington. In the form of a stylised owl whose head is the lid. A work that is easily appreciated for the immediate and striking effect of its decorative motifs.

27. Bronze vessel inlaid with gold and silver. 5th–4th centuries BC. Freer Gallery of Art, Washington. This form, with its stem, semi-spherical body, lid and lateral rings, is characteristic of late Chou but has forerunners in proto-historic clay production.

28. Zoomorphic vessel in the shape of an elephant with finely incised decoration. Early Chou. Musée Guimet, Paris. The animal which has become almost a figure of fantasy, in spite of the stylisation, this old rogue still retains a remarkable feeling of strength.

29. Vessel of inlaid bronze. Hu type with lid. 'Warring States' period (481–222 BC). Vannotti Collection, Lugano. The decoration which completely covers the body of the vessel is typical of the Huai style, embossed in red with stylised dragons and birds.

30. Broad cup-shaped basin with dragon handles. Middle Chou period. Musée Guimet, Paris. In this work the notable elements are the high base and the handles. A typical decoration of the period is incised on the exterior. The same form of basin will be reproduced in jade later during the Ch'ien Lung period.

31. Rectangular ritual vessel with four legs. Chou period. W. Rockhill Nelson Gallery of Art, Kansas City. Fang ting type. The regular geometrical decoration in high relief incised on the sides, the projecting decorative motifs on the corners and the facing animals on the handles, identify the work as a product of the early Chou period.

32. Bell with decorated handle. Chung type. Early Chou. W. Rockhill Nelson Gallery of Art, Kansas City. The decoration is incised in a horizontal pattern broken in the centre by a vertical strip. The truncated conical knobs on the sides, produced during the casting, increase the solidity and resonance of the object, which was beaten with a bronze rod.

33. Round vessel lid. Early Chou. Musée Guimet, Paris. This is surmounted by a stylised image of a bird which, as a result of the distortion of its natural proportions in the details, becomes an abstract sculpture or rather a biomorphic abstraction. The perforated crest, the sharp projecting beak and the bulging eyes suggest a woodpecker in spite of the talons, which are those of a bird of prey.

34. Vessel with hinged handle. Yü type. Early Chou. Freer Gallery of Art, Washington. The decoration, based on large T'ao-t'ieh masks, was produced during the casting and hand-finished with a burin.

35. Bronze basin with handles formed by elephant heads. Early Chou. Musée Cernuschi, Paris. This piece has geometrical motifs on the sides and, on the unusual tall rectangular base, an undulating stripe which evokes the idea of the cosmic mountains. Under the rim there is a small T'ao-t'ieh head which is vaguely naturalistic despite the stylisation of the detail.

36. Wine vessel. Lei type with T'ao-t'ieh decoration. Early Chou. Nezu Art Museum, Tokyo. The lid, which is surmounted by a characteristic mushroom-shaped knob, evokes the form of a hut roof and, with the monstrous masks on the shoulders of the vessel, has a symbolic meaning.

37. Ritual bronze basin. Kuei type. Early Chou. W. Rockhill Nelson Gallery of Art, Kansas City. The decoration in high relief extends to the tall square base. The principal motif, as can be readily seen, is that of the T'ao-t'ieh image, discomposed in various ways but with accurately described eyes. Looped handles and small decorative symbolic heads complete the composition.

38. Ornamental plaque with a very stylised carnivorous animal with head turned. Ordos art. British Museum, London. The paws disappear in the curvilinear abstract motif. The recessions and harmonious perforations reveal a taste for lively images and indicate the effects that can be enjoyed by placing the object on a coloured ground.

39. Ornamental silver plaque of a mule or wild ass. Ordos art. British Museum, London. The animal is shown at full gallop, with all four legs off the ground. The stylised hooves are set with precious and semi-precious stones, like the mane, ears, and the round points of the leg joints. This is jewellery derived from work in bronze.

40. Small ornamental bronze plaques. Ordos art. Musée Cernuschi, Paris. One of these small plaques represents a goat with a kid, the other a deer at full gallop. The stylisation, which is very marked (especially in the deer), shows the influence of Siberian art.

41. Deer at full gallop. Ordos art. Musée Cernuschi, Paris. This figure in the round has a highly stylised face and posture but retains a naturalistic element, probably derived from the Siberian culture of Tagar. Note the feeling of tension the figure conveys.

42. Tripod incense burner. Chou period. Metropolitan Museum of Art, New York. Rogers Fund, 1947. The decoration on the round body of the vessel imitates rush weave and is enriched by the addition of fantastic animals. The bird which serves as a lid handle is a phoenix ('feng-kuang' in Chinese). The four minor figures of the same bird represent a spatial symbolism which symbolises the whole universe. Dragons and serpents complete the decoration.

43. Small bronze horse from Central Asia. Early Chou period. W. Rockhill Nelson Gallery of Art, Kansas City. The stylisation of this figure in the round does not conceal the sculptor's keen observation, which has captured the animal's most important characteristics.

44. Buckle shaped like a bird. Han period (1st–2nd centuries AD?). Musée Cernuschi, Paris. J. Coiffard Collection. The stylisation is ribbonlike, as in work done in lacquer, and the different parts of the bird are discomposed and arranged as abstract decorative elements along the line which represents the body. The two wings and tail form a very decorative abstract composition based on elipsoid spirals.

45. Figure, perhaps female (a bird trainer?). Late Chou (3rd century BC?). Museum of Fine Arts, Boston. From Chin-ts'un near Loyang. The squat image with its Mongolian face gives all its attention to the perches on which sit two jade pigeons. The dress and hair style are barbarian.

46. Bronze figure of a juggler with a performing bear. Late Chou. Freer Gallery of Art, Washington. The dress and face of the man clearly show his northern barbarian origin. The bear on top of the pole is modelled with remarkable naturalism.

47. Bronze support in the form of a bear. Han period. British Museum, London. Although the figure is rather squat, it has strongly naturalistic characteristics and is well balanced: it portrays faithfully the Siberian symbolism of the bear as the demon of darkness.

48. Bronze kneeling figure making an offering. Late Chou. W. Rockhill Nelson Gallery of Art, Kansas City. Probably from Chin-ts'un near Loyang. Its heavy build is reminiscent of the juggler with the bear but its greater stylisation makes it a less admirable work. It was probably used as a support.

49. Gilded bronze figure inlaid with gold and silver. 1st–2nd centuries AD. British Museum, London. A Muntjak sheep with one horn. This tiny animal is a characteristic product of Han naturalism but the single horn gives it a fantastic and symbolic character.

50. Bronze vessel. Hu type, inlaid with gold and silver Early Han. Museum of Fine Arts, Boston. The two figured bands. correspond stylistically to the art of stone funerary slabs of the Han period. The exact meaning of the incised figures is lost but the upper band with an animal motif certainly alludes to the supernatural world; the figures with the carts in the lower band probably represent good creatures.

51. Back of a bronze mirror with characteristic TLV decoration. Han period (206 BC– AD 25). Musée Cernuschi, Paris. Coiffard Collection. An interesting design based on a circle which encloses a square round another circle. The composition is clearly symbolic and is enlivened by demons and other fantastic animals. The long inscription in archaic characters is almost certainly of a magical character.

52. Back of a bronze mirror with decoration in relief. T'ang period. (AD 618–906.) Musée Cernuschi, Paris. Coiffard Collection. The ring of five horses in the centre is reminiscent of the 'vertigo of flight' decoration. The outside band, on the other hand, is decorated with grape motifs (of Iranian origin) and stylised flowers, birds and leaves.

53 Back of a bronze mirror, plated with gilded silver. T'ang period. Vannotti Collection, Lugano. This piece shows seven stylised lions in strong relief—one as the central boss—and decoration with vine leaves and grapes in the Iranian (Sassanid) style. Three birds of good omen complete the composition.

54. Back of a lobed bronze mirror covered with gold. T'ang period. Freer Gallery of Art, Washington. Decoration based on foliage and birds of good omen; the arabesque is based on heart-shaped motifs enclosing four birds. Probably in the style of Indo-Iranian compositions.

55. Back of a 'good luck' wedding mirror. Middle T'ang period (7th–8th centuries AD). Freer Gallery of Art, Washington. Bronze covered with silver and inlaid with gold. The decoration is mostly based on stylised arabesques of foliage. Two phoenixes, a lion and a winged horse complete the composition, which is, in part, of Iranian origin.

56. Back of a bronze mirror, covered in gold and silver. T'ang period. Metropolitan Museum of Art, New York. Rogers Fund. The inscription, beautifully worked, expresses good omens as do the phoenixes, which are poised lightly and gracefully on tiny clouds in the centre of the composition.

57. Goblet-shaped incense burner. Early Han dynasty (3rd century BC) or earlier. Freer Gallery of Art, Washington. The perforated lid on this work also refers to the Island of the Immortals. The decoration is inlaid gold and silver, semi-precious stones and turquoise. On the base there are figures of dragons which express the divinity of the earth (underground) and of water.

58. Buddha, perhaps Maitreya (Mi-lo), the Buddha of the future. Six dynasties, Northern Wei. Metropolitan Museum of Art, New York. Kennedy Fund, 1926. Gilded bronze. The inscription shows a date AD 477–486 (the 24th day of the first month of the tenth year of Tai Ho). However, the inscription could be a modern forgery, though the work is genuine. In the abstract treatment of the drapery there is a Greco-Buddhist influence from Gandhara, transmitted through Central Asia, which also appears in Shansi works in stone.

59. Statuette of the Maitreya cult. Dated AD 531. Private collection, Prague. This piece is identifiable by the vase of immortality held in the right hand. The statuette stands on a lotus, upside down, which rests on an elegant stand. Behind it is a halo of stylised flames from which project three images of Buddha expressing his omnipresence. The head of the figure is derived from the Mathura heads of the Gupta period and depicts a clearly Indian type.

60. The Sakyamuni Buddha with hand positions which show absence of fear (right hand) and the act of giving (left hand). Northern Ch'i dynasty (second half of 6th century AD). W. Rockhill Nelson Gallery of Art, Kansas City. The face of this image, which sits on a lotus, is powerfully rendered. The stylisation of the draperies is lively, particularly in the lower folds.

61 Bronze altarpiece. Dated AD 593. Museum of Fine Arts, Boston. The supreme Buddha Amitabha in his paradise surrounded by attendants. The Bodhisattva Avalokitesvara with the pomegranate symbol, which signifies fertility, is placed on the right; on the left is the Bodhisattva Mahasthamaprapta in an attitude of prayer. Each stands on a lotus flower.

62. Sakyamuni. Buddha making the gesture of reassurance. Northern Wei (about the middle of the 5th century). W. Rockhill Nelson Gallery of Art, Kansas City. The upraised hand is a symbol of wisdom and its form derives from a technical development in Gandhara stone sculpture. The stylised dress is a superb Chinese interpretation of the drapery of an Indian monk's habit.

63. Gilded bronze ornament or altarpiece. Early 7th century. Museum für Ostasiatische Kunst, Cologne. The seven Buddhas of the past seated on lotus flowers. In the important central position is Sakyamuni flanked by his predecessors, who were unable to transmit the law as he did.

64. The Sakyamuni Buddha seated on the corolla of a lotus. Gilded bronze. T'ang period. Metropolitan Museum of Art, New York. Rogers Fund, 1943. The hands are in the attitude of prayer (dharmacakra-mudra). The long almond-shaped eyes give the face an expression of impassivity. The design of the drapery is Indian in origin but interpreted in the Chinese manner.

CONTENTS

Page